Come My Children

WOMEN'S VOICES FROM GAZA

Come My Children

HEKMAT AL-TAWEEL

Ghada Ageel
& Barbara Bill
Editors

UNIVERSITY
of **ALBERTA**
PRESS

Published by

University of Alberta Press
1-16 Rutherford Library South
11204 89 Avenue NW
Edmonton, Alberta, Canada T6G 2J4
amiskwaciwâskahikan | Treaty 6 | Métis
Territory
uap.ualberta.ca | uapress@ualberta.ca

Copyright © 2023 University of
Alberta Press

LIBRARY AND ARCHIVES CANADA
CATALOGUING IN PUBLICATION

Title: Come my children / Hekmat
 Al-Taweel ; Ghada Ageel and Barbara
 Bill, editors.
Names: Al-Taweel, Hekmat, 1922-2008,
 author. | Ageel, Ghada, 1970- editor. |
 Bill, Barbara, 1956- editor.
Description: Series statement: Women's
 voices from Gaza series | Includes
 bibliographical references.
Identifiers: Canadiana (print) 20230169104 |
 Canadiana (ebook) 20230169139 |
 ISBN 9781772126761 (softcover) |
 ISBN 9781772126921 (EPUB) |
 ISBN 9781772126938 (PDF)
Subjects: LCSH: Al-Taweel, Hekmat, 1922-
 2008. | LCSH: Christian women—Gaza
 Strip—Biography. | LCSH: Christian
 biography—Gaza Strip. | LCSH: Gaza
 Strip—History—20th century. |
 LCGFT: Autobiographies.
Classification: LCC DS110.G3 A48 2023 |
 DDC 956.94/3—dc23

First edition, first printing, 2023.
First printed and bound in Canada by
Houghton Boston Printers, Saskatoon,
Saskatchewan.
Copyediting by Kay Rollans and
Angela Pietrobon.

Proofreading by Kay Rollans.
Maps by Wendy Johnson.

University of Alberta Press gratefully
acknowledges the support received for its
publishing program from the Government
of Canada, the Canada Council for the Arts,
and the Government of Alberta through the
Alberta Media Fund.

To those who struggle for justice.

Contents

Preface

Introducing Women's Voices from Gaza

THIS BOOK IS THE THIRD VOLUME of the Women's IX

Voices from Gaza series. This series of seven stories recounts life in Palestine, prior to and after its destruction, narrated by women who lived through those experiences. The collected corpus of their accounts offers a vivid picture of a people: the places and individuals, both past and present, of Palestine. It traces Gaza's history, a rich tapestry woven of many strands.

The oral history accounts recorded in this series complement a body of work asserting the centrality of the narrative of Palestinians in reclaiming and contextualizing Palestinian history. The research, through which these testimonies were located, solicited, documented, and gathered into a whole, aims to reorient the story of Palestine by restoring it to its original narrator: the Palestinian people. In addition, the focus of this series is on Palestinians who live or lived in the Gaza Strip, whether prior to or as a result of the *Nakba*, the 1948 catastrophe that led to the collective dispossession of the Palestinian people.

While other works, such as those of anthropologist and historian Rosemary Sayigh, have aimed at "narrating displacement" as a defining experience of Palestinian people in modern times,[1] this series describes life both before and

after the *Nakba* as it was lived by the narrators in different parts of Palestine—in Jaffa, Beit Affa, Beit Daras, Beit Hanoun, Khan Younis, Bureij, and Gaza—and in exile. More specifically, it provides a full account of life in different parts of historic Palestine, starting from pre-*Nakba* times, through the destruction of Palestine's villages and towns and the dispossession of their inhabitants in 1948, to the Israeli invasion and occupation during the Swiss crisis in 1956, the war followed by military occupation in 1967, displacement and exile, two *Intifadas*, and a failed peace process leading to the current impasse. While the series brings to the forefront experiences of normal life before displacement, dispossession, exile, wars, and occupation, the accounts also brilliantly illuminate much of the small, everyday detail of lives in villages and towns. They recount rituals associated with agrarian cycles, wedding rites, and rites accompanying birth and death, as well as aspirations, fears, and hopes. Readers are invited to reimagine Palestine and the lives of those side-lined by traditional history.

Unlike some approaches, where essentialized framing of oral histories collected from displaced and refugee women has allowed researchers to "reinterpret" the outcomes of their research, our narrators own and have determined their narratives. Consequently, these are presented in all their complexity, fertility, and normality. Through their deep collective memories, each individual woman transmitted her own narrative/history, embodying a chapter of Palestine's neglected history. Following Edward Said's observation that "facts get their importance from what is made of them in interpretation...for interpretations depend very much on who the interpreter is, who he or she is addressing, what his or her purpose is, at what historical moment the

interpretation takes place,"[2] our effort has been to seek out and foreground the narratives of Palestinian women with minimal interference. This has allowed the women unhindered ownership of their own story, with only minimal intervention or interpretation on our part. Our sole interference in each woman's text was editing and positioning it so as to give it greater fluidity and allow it to read as a cohesive piece.

In contrast to works that have focused on women living in urban areas or on experiences of displacement, this series engages with women from both the urban and rural parts of the Gaza Strip, and with Indigenous women as well as refugees and returnees (women who had been exiled and were able to return to Gaza following the Oslo Accords). Although Gaza is small, it is densely populated, and small geographic variances may have significant impacts on how life is experienced. Life in rural parts of the Strip can be very different from urban life, and Indigenous vs. refugee backgrounds make for distinctly different life stories. Such considerations help move us toward a more fully comprehensive and representative account of life in this part of historic Palestine, both prior to and after 1948.

Unsurprisingly, many of the details of the stories recorded in this series overlap, although the women telling them are unlikely to have met each other. This universality of experience provides a multi-layered map in which human history becomes political history, allowing readers an opportunity to see into the heart of life as it was lived in these spaces from day to day. Individually and as a cumulative corpus, the stories offer a new contribution to the fields of both Palestinian oral history and women's studies.

The life stories collected and presented are those of women from distinct, differing backgrounds: a refugee from Beit Daras village living in the southern part of the Gaza Strip (Khadija Salama Ammar, Khan Younis refugee camp); a refugee from Beit Affa village living in the central Gaza Strip (Um Jaber Wishah, Bureij refugee camp); a refugee from Jaffa City living in the north of the Strip (Um Said Al-Bitar, Hay Al-Naser in Gaza City); a villager living in the north of the Gaza Strip (Um Baseem Al Kafarneh, the border town of Beit Hanoun); an Indigenous Christian resident of Gaza City (Hekmat Al-Taweel); a returnee to the Gaza Strip, originally a resident of Gaza City who was displaced and became a refugee after the 1967 war (Sahbaa Al-Barbari); and an Indigenous resident of the Gaza Strip living in Khan Younis City who subsequently moved to Gaza City (Madeeha Hafez Albatta).

The seven participants were interviewed over two years in the midst of an acutely difficult period: the late 2000s during the second *Intifada*, while freedom of movement within the Gaza Strip was severely restricted. The women interviewed were carefully selected to represent a variety of backgrounds, whether religious or socioeconomic, with different personal statuses and very distinct trajectories. Several parameters such as refugee vs. Indigenous background or rural vs. urban experiences determined the editors' selection of interviewees, in an attempt to record Gazan women's knowledge from a broad spectrum of individual standpoints.

We interviewed each woman in her home or on her farm. In most cases, we met with and interviewed them on their own. In some cases, other family members were present. Interviews in the presence of younger people and

particularly in the presence of daughters-in-law tended to arouse a great deal of excitement and astonishment, often expressed in a mixture of laughter and tears. These occasions were clearly learning experiences, enabling others as well as the interviewers to join these brave women in exploring and narrating hidden chapters of their lives. Each of our interviewees courageously revealed moments of pain, joy, distress, peace, and uncertainty, along with the abiding hope that they had sustained over decades.

Our interviews with each of the women were audio-taped, producing hundreds of tapes that were then carefully transcribed and translated. One of us is a native speaker of Arabic, which facilitated the translations, and the other is a native speaker of English, which much improved the abbre-viated English narratives. In a thorough, nuanced process, we returned to each interviewee with multiple questions and requests for clarification, with the result that the research and editing required a full three years. We checked factual details against known events to ensure the accuracy of each story, which we compiled in a way that would ensure the narrative's continuity, cohesion, and harmony.

The narratives, translated as they were told, remain faithful, honest accounts of these women's lives.

Foreword

AFTER FINISHING a doctorate in political history, I was introduced to the rich world of social history. Political history chronicles political elites and their motives, actions, and policies. Social history taught me that the field of history could be a far more ambitious enterprise than that; it could seek to reconstruct as many aspects of as many people's lives as possible. Social historians include women, children, workers, minorities, slaves, Indigenous and colonized people, and many other groups who for many years have been excluded from Western historiography.

History can also be about the daily experience of people, not as numbers or statistics, but as individuals with names, feelings, and personalities. Historians need to familiarize themselves with anthropological methodologies of observation and listen to people's narratives. This has produced the most contentious yet most exciting historiographical genre of our time: oral history.

One of the books that introduced me to the power of this "history from below" and persuaded me that a historian cannot reconstruct people's pasts without anthropological approaches or the patience and imagination of a writer was *Khul-Khaal: Five Egyptian Women Tell Their Stories* by the

Egyptian-American oral historian, writer, and translator Nayra Atiya (who later also wrote *Shahaama: Five Egyptian Men Tell Their Stories*). Five Egyptian women between the ages of twenty and about sixty-five and from different socioeconomic backgrounds tell their life stories in this book. Their daily activities, dreams, thoughts, tragedies, and moments of elation give us as readers an insight into women's life in modern-day Egypt, which very few dry academic works could have hoped to do. It is not filtered through a complex theoretical discourse nor is it a faceless introduction into their lives; it is an accessible tale full of smells, sounds, and colours, providing a thick picture of women's lives in Egypt with all the hardships and opportunities they offer.

I was thinking of *Khul-Khaal* when reading Hekmat Al-Taweel's story of her life as a Christian woman from Gaza. It carries the same quality and inspires the same deep reactions from the reader. Such projects often do. The intimacy of this particular volume, with Hekmat's accessible, not professional, but definitely literary prose and clear narrative, immediately offers the reader an authentic report of what it means to be a Palestinian woman living through some of the more horrific and heroic junctures in Palestine's history.

This is not only a fine book in the tradition of seminal works such as *Khul-Khaal*; it is a wonderful work of oral history that offers vital details to counter the Zionist narrative of Palestine. Even today we have to justify granting oral histories the same academic credibility we give to histories based on archival material. Palestinians are fragmented, oppressed, dispersed, their archives looted and destroyed. Yes, they are rebuilding their archival infrastructure, but under impossible circumstances. They are gathering private collections once more, deconstructing available Israeli

archival material, and relying on foreign archives, but none of these resources would provide sense and orientation for the Palestinian narrative without oral history. The dominant presence of oral history in Palestinian historiography helps Palestinians own their narrative. This incredible book shows precisely how an oral history, narrated by one woman and about a history that stretches from the Mandate period in Palestine to our times, is more than just a personal angle on history; it contains all the most important ingredients of what it meant and means to be a Palestinian in general, and a Palestinian woman in particular.

One of the crucial aspects of being a Palestinian that emerges so powerfully from Hekmat's narrative is her reference to the *Nakba* on one hand, and to the Palestinian resilience in facing its consequences on the other. We are aware of course that the *Nakba* constituted an ethnic cleansing operation that led to the expulsion of half of Palestine's population, the destruction of half of its villages, and the de-Arabization of many of its towns. What is sometimes missed is the way it has disrupted and in many cases, including the one narrated here, ended successful careers, chances of improving socioeconomic conditions, and opportunities to fulfill hopes for a better future and a normal life with all its ups and downs. Hekmat's story shows us how the *Nakba* robbed Palestinians of even the most mundane moments of life, such as going to the *hammam* or picnicking on the beach. These moments are still are missing in the lives of so many Palestinian children, who cannot go to the sea if they live in the West Bank and are in danger of being killed by the Israeli army if they go the Gaza beach. Of course, ordinary life is not just moments of fun and pleasure, and Hekmat does not shy from sharing with us her daily challenges—for example,

those of being young bride in a household where her mother-in-law is in charge. But these challenges, too, are what normality is all about—what is longed for, and what has been taken away by oppression.

This natural course of life was cut off, leaving more than a million Palestinians in limbo. Their careers disrupted and their life patterns and hopes for the future shattered, Palestinians continue to be punished because of who they are, treated as "aliens" by a settler colonial movement motivated by what Patrick Wolfe called the logic of "the elimination of the native."[1] This approach has led to Israel's ethnic cleansing of Palestine in 1948—a crime against humanity—and to a series of war crimes and violations of human rights that continue to this very day. It is a criminal policy still not acknowledged by Western governments, although it is condemned by Western civil society, which has recently quite clearly and boldly depicted Israel as an apartheid state.

Hekmat did not allow the trauma of the *Nakba* to define her only as a victim. This brave and outspoken Palestinian woman insists on her agency. Through unbelievable resilience, sometimes referred to as *Sumud*, she finds the power to struggle for existence and freedom. Hekmat is not just a victim of the policies of ethnic cleansing, occupation, and siege; she is someone who has the tenacity to rebuild her life despite the ongoing injustices affecting her since 1948.

Hekmat's story should be read in conjunction with the many other authentic stories recorded in collections and books, and should be appreciated as very unique contribution to the diversity that makes up the Palestinian experience. Each story—not just Hekmat's or, for that

matter, that of Ghada Ageel, one of the editor of this series[2]—is worth reading and listening to.[3]

Hekmat's story depicts the tragedy of the *Nakba* as experienced by a middle-class, relatively affluent family forming part of a social class that any society in the mid-twentieth century needed in order to modernize. Other Palestinians came from humbler origins, and therefore their experiences of exile and resilience and their dreams of liberation will be somewhat different. Still there are many common features to all of these experiences; these form the backbone of the Palestinian revival after the *Nakba*. For example, as Mahmoud Darwish's beautiful and painful assertion reminds us, Palestinians suffer from the incurable disease of hope.[4]

Another common feature is the organic links between Palestine and the rest of the Eastern Mediterranean. Until 1948, there were no borders between Gaza, Cairo, Beirut, and Damascus. Palestine's culture informed the *Mashriq* culture and was fertilized by it.[5] The *Nakba* cruelly lobotomized Palestine out of *Mashriq* culture and life. In addition to this loss, the mosaic of religions, ethnic groups, and cultures that coexisted through an adherence to genuine principles of "live and let live" were replaced throughout the region by imperialist-induced sectarianism constantly threatening to tear countries apart.

In this respect, Hekmat brings to the fore both Christian-Muslim and Arab-Jewish relationships in the period before and after the *Nakba*. As we learn from so many recent recollections, co-existence—a most abused term—was a genuine reality in Palestine, whether in the rural areas or in the cities. Zionism, fragmentation, divide-and-rule polices, and despair created isolation among communities that used to live organically together.

Foreword

The genuine spirit of co-existence in Palestine, a defining characteristic of life before the *Nakba*, also helped traumatized Palestinian communities confront the immediate consequences of the *Nakba* in the early years after it occurred. Poor and small Palestinian communities hosted refugees, providing from their meagre resources for a population that was suddenly double or even triple the community's original size, sometimes for a period of up to two years. On a more personal level, in Hekmat's story, we learn about the adoption of Muslim babies by Christian families, two communities who lived together until 1948.

The imbalance of power between Israelis and Palestinians is such that only through books like this one can we realize what means Palestinian people possess today to survive and navigate their lives under impossible conditions. John Collins describes this imbalance as the result of global structural injustices:

> *Palestine is located at the intersection of two sets of global processes that symbolise not only the profundity of the structural injustices that are being confronted today, but also the resilience and creativity with which many people are confronting those injustices.*[6]

One way of navigating this intersection is by using the power of memory. This is why memory plays such an important role in the Palestinian individual and collective identity, sustaining the struggle for liberation and freedom. Memory helps not only to define one's identity, but also to propel a younger generation to continue the struggle of the older one. Hekmat's political activism began when she participated

as a young girl in the anti-Mandate demonstrations and continued throughout her life.

Finally, Hekmat's observing eye debunks for us the famous Zionist propaganda that Israel caused the desert to bloom. Her description reveals quite the opposite. A she describes it, Gaza was a beautiful, blooming land to 1948; the Zionist movement made it into a landscape of slums and refugee camps. Still, it is possible to imagine different scenery unfolding one day in the future.

ILAN PAPPÉ, 2022
Professor of History and Director of the European Centre for Palestine Studies, University of Exeter

Acknowledgements

THIS BOOK AND SERIES would not have been possible XXIII
without the support and love of several people who were
extremely generous with their time, comments, directions,
and encouragement. For all of them, we are sincerely
grateful and are eternally indebted.

We will begin by expressing our appreciation to the
amazing seven narrators of this series, Hekmat, Madeeha,
Sahbaa, Khadija, Um Baseem, Um Jaber, and Um Said, and
their families, for so generously sharing their stories and
making us welcome in their homes.

We are grateful to our friend Shadia Al Sarraj for her
friendship, remarkable support, and encouragement.

We would like also to thank the former editor at the
University of Alberta Press, Peter Midgley, for supporting
this project, and the amazing current editor of the Press,
Mat Buntin, who helped us throughout the process of
writing by answering queries and providing all forms of
support. A special thank you to Cathie Crooks for all her
incredible support and to all the talented team at University
of Alberta Press.

Sincere thanks to John Pilger, Wayne Sampey, and the late Inga Clendinnen for their assistance, support, and encouragement.

Several people have generously expended time and effort to read sections of our work and offered valuable advice. Professor Rosemary Sayigh deserves special thanks for her generosity in providing us with useful comments. Sincere thanks go to Rela Mazali, Terry Rempel, and Eóin Murray for reading and commenting on parts of the introduction. We are also grateful to Nour Khalil Abu Shammala and Ghaida Abdelnasser Hamdan for providing several photos from Gaza. Special thanks and unending gratitude to Andrew Karney for all his support, encouragement, and friendship. We also would like to thank Wejdan Hamdan for helping with the transcription of the stories. She has dedicated many hours in support of this project, which she calls a labour of love and resistance.

Finally, thanks to our late parents, who never gave up hope that these narratives would be published.

Acknowledgements

Introduction

IN PERFORMING their assigned gender roles as life-givers,
keepers of family tradition, and culture bearers, Palestinian
women have created, practised, and continue today to prac-
tise forms of resistance to generations of oppression that are
largely underreported and unacknowledged. This is the case
in virtually every part of historic Palestine, but it is partic-
ularly true of the Gaza Strip. The Gaza Strip, often referred
to simply as "Gaza," is a small, hot-button territory on the
eastern shore of the Mediterranean Sea, 40 kilometres long,
with a width that varies from 6 kilometres in the north to
some 12 kilometres in the south. Despite its significance
as the heartland of the Palestinian struggle for freedom
and rights, the history of the place and its people is often
deformed by simplified discourses or reduced to a humani-
tarian problem and a contemporary war story. The recurring
pain and loss its people face are offset by life and vibrancy,
by playful and earnest children, by ambitions and dreams.

Around 1.4 million refugees live inside the Gaza Strip
(forming some 18 percent of a worldwide total of 7.9 million
Palestinian refugees).[1] For Palestinians and Palestinian refu-
gees in general, but especially for those living in Gaza, the
central event in the narrative of their lives is the *Nakba*

(the 1948 catastrophe), which led to the dispossession of the Palestinian people, displacing them, appropriating their homes, and assigning them the status of "refugee." In the history of Palestine and Gaza, the catastrophe of collective dispossession is a shared focal point around which they can congregate, remember, organize, and "struggle to reverse this nightmare."[2] Rather than allowing the memory of the *Nakba* to dissipate, time has deepened and extended the communal consciousness of sharing "the great pain of being uprooted, the loss of identity."[3]

In his anguished plea for the departure of "those who pass between fleeting words," the Palestinian national poet Mahmoud Darwish calls for the departed to leave behind "the memories of memory."[4] Darwish's poem is a cry for the value of memory, for the deployment of words, stories, and narratives in the battle for justice. Words and memories, Darwish said, matter. But he also recognized that dispossession is a function of the Palestinian national story. Among the list of items stolen are the blueness of the sea and the sand of memory. These phrases could be references to numerous sites in historic Palestine, but Gaza would have to be among them. There, the blueness of the sea is still available to Palestinians, but the sands of its beaches offer little comfort to those who remain uprooted from the soil of their ancestral homes (among them, one of the editors of this work, who grew up a short distance from one of Gaza's most famous beaches, Al Mawasi, looking at it from among the dense, grey crowd of houses that make up the Khan Younis refugee camp).

In Palestinian legal, political, social, and historical discourses, the *Nakba* constitutes the key turning point. The rights to which Palestinians are entitled under international

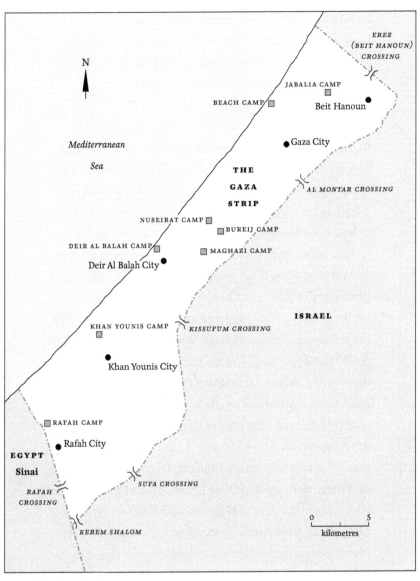

The Gaza Strip.

law are the shifting benchmarks these discourses and narratives seek to restore. The memories that they struggle to keep alive are sites of resistance against the obliteration of history and the erasure of a vibrant culture.

Gaza's History

In putting together this series, we seek to bring attention to just a few strands of the myriad individual narratives comprising the Gazan tapestry. As we explain below, each story has been woven into the series in nuanced awareness of how it relates to the larger context unfolding at the time.

This larger story is multi-faceted. However, its discrete and varying facets share a common sense of abandonment. Virtually all Palestinians have been abandoned and, in fact, suppressed. That this suppression has taken place through the actions of a group of people who themselves were abandoned and oppressed is one of the most painful ironies of this conflict. When Palestinians cry from the pain of their *Nakba*, this cry comes directly as a mirror of the pain of the Jewish Holocaust—the pain of the Jewish people escaping concentration camps and genocide in Europe. There were cases of people who wanted shelter, security, and freedom. And there were cases of those driven by the Zionist ideology, which, since the days of Herzl and the Basel Congress of 1897, placed a premium on securing a homeland for the Jewish people above all other considerations, including the rights, dignity, and protection of Palestinians.

Palestinians have been abandoned by the world, whether by colonial protectorates like Britain, who signed over "their" land to the Jewish people through the 1917 Balfour Declaration—violating the well-established legal maxim that nobody can give what he does not possess—or by some of

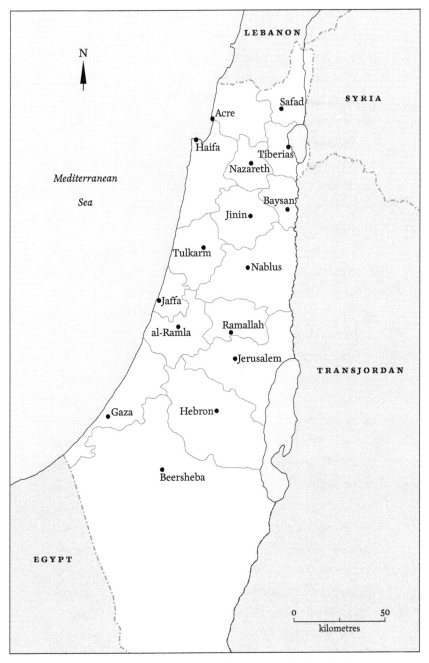

Palestine, 1947: districts and district centres during the British Mandate period.

today's Arab regimes, mainly the Gulf countries led by Saudi Arabia, who view their common enmity for Iran and alliance with the American Administration as justification for steadily siphoning off the rights of Palestinians. The latter creates a sense that the Palestinian cause has lost its status as *cause célèbre* of the region and that the Palestinian people are becoming mere footnotes in regional politics. Perhaps most tragically of all, they have been abandoned by both recent and current Palestinian leadership, who have signed peace deals without addressing the core issues of their struggle: the right of return and the 1948 *Nakba*.

It is no wonder, then, that a second strand of the Palestinian narrative is that of alienation from, and lack of faith in, the political structures that should supposedly achieve legitimacy for the rights that Palestinians yearn for so passionately.

Gaza, from a birds-eye view, has always been subject to abandonment and suppression. Its location is of strategic significance: a crossroads between Palestine and the lands to the south (Egypt), Israel (today) to the north, and Europe to the west. The future capital of the unborn Palestinian state, occupied East Jerusalem, is just a short hour-and-a-half drive to the east. Under the British Mandate (1922 to 1948), Gaza was one of the six districts of Palestine. When the United Nations voted to partition the country in 1947, Gaza was to be one of the main ports for the future Palestinian state. Successive Israeli governments have consistently deemed the place and its people a problem and a perpetual security threat. In idiomatic Hebrew, the expression "go to Gaza" means "go to hell."[5] Even within the Palestinian narrative, Gaza's history has been pushed into the margins.

The UN library contains a vast body of documentation of the processes and consequences of Palestinian dispossession and occupation, whether economic, social, or legal. Alongside the catalogue of resolutions concerning peace, statehood, and rights (UN Resolutions 181, 194, and 242), the UN has also described the Palestinian refugee situation as "by far the most protracted and largest of all refugee problems in the world today."[6]

In 2012, a UN report predicted that Gaza could be rendered completely uninhabitable by 2020.[7] This bizarre prediction is consistent with the notorious Zionist image of Palestine as "a land without a people."[8] This image has now morphed into one in which a piece of that land has become unfit for human habitation, when its inhabitants number far more than they have at any other point in its history. Perhaps this uncomfortable contradiction epitomizes the core of what should be said about the recent history of Gaza in explaining the current Kafkaesque predicament of its civilian population. Undoubtedly, Mahmoud Darwish would have relished its poignant irony.

Gazan life in the early half of the twentieth century was largely agrarian and market based for its eighty thousand inhabitants living in four small towns: Gaza, Deir Al Balah, Khan Younis, and Rafah.[9] Even the most urbane of the Strip's original inhabitants professed a deep connection to the homeland, and the most harried and overextended of Gaza's lawyers and doctors made time to nurture fig trees or raise chickens. However, the situation changed dramatically with the 1948 *Nakba* when over two hundred thousand refugees arrived on the tiny strip of land, after simply travelling down the road without crossing even a single international

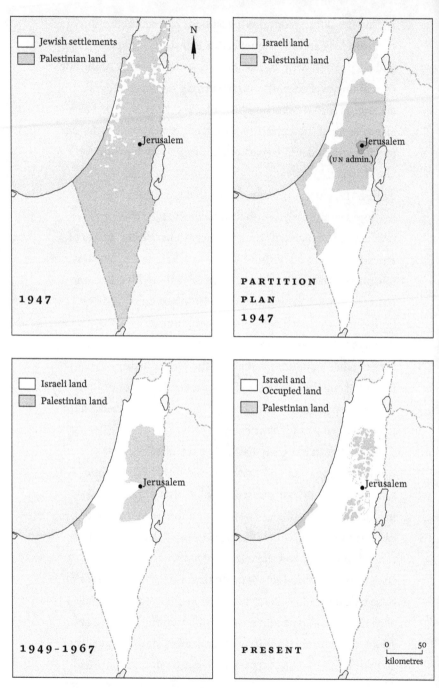

The loss of Palestinian land from 1947 to present.

border, looking for safe haven.[10] Many of them imagined a sojourn in the Strip, probably for a "few days or weeks."[11] The establishment, in 1949, of the United Nations Relief Works Agency for Palestinian Refugees (UNRWA) to provide vital services such as education, health care, and social assistance seemed to consolidate the status of these displaced persons, despite their abiding hope for "return." Those who attempted to materialize that hope were forcibly prevented from returning and sometimes killed by Israeli forces. According to Israeli historian Benny Morris, in the period between 1949 and 1956, Israel killed between 2,700 and 5,000 people trying to cross the imaginary line back to their homes.[12] Over time, the tent camps turned into concrete cities, where the politics of resistance incubated that would later flourish.

Egypt controlled the Gaza Strip until 1967. During the Suez Crisis of 1956, Israel occupied the Strip temporarily and committed massacres in Khan Younis and Rafah before Israel's military was forced to withdraw. In Khan Younis alone, Ihsan Al-Agha, a local university teacher, documented the names of hundreds of people killed.[13] This period was signified by the rise of the *Fedayeen* movement—a national movement of Palestinian resistance fighters who attempted to mount attacks against the State of Israel, which had occupied and destroyed their homeland. In order to deter Palestinians, Israel constantly attacked and bombarded Gaza. In August 1953, the Israeli commando force known as Unit 101, under the command of Ariel Sharon, attacked the Bureij refugee camp, east of Gaza City, killing over forty people. Two years later, in 1955, the Khan Younis police station was blown up, leaving seventy-four policemen dead.[14] This period also witnessed tensions between the Egyptians

and Palestinians against the backdrop of the Johnson peace proposal in 1955.[15] Endorsed by the UN and the Egyptian government, the proposal sought to resettle Gazan refugees in the northwest of the Sinai Peninsula. Popular demonstrations protesting the plan were directed against both the UNRWA and the Egyptian administration in Gaza.[16] This wave of focused activism was the context in which the seeds of the Palestine Liberation Organization (PLO) were sown.

The war of 1967, known colloquially as the Six-Day War, left the Gaza Strip and the West Bank, as well as the Syrian Golan Heights and the Egyptian Sinai Peninsula, occupied by Israel. Soon after the war, Israel enacted the annexation of East Jerusalem. These developments generated a new set of legal and political structures that extend to the present day. In East Jerusalem, Israeli law applies to all citizens (whether Palestinian or Jewish). However, the Palestinian residents of East Jerusalem are required to hold special ID documents and they are not entitled to Israeli citizenship (unlike the Palestinian Arab citizens of other areas inside Israel, such as Nazareth). In the West Bank and Gaza Strip, the "occupied territories," Israeli military law was applied. When Jewish settlements were introduced (that is, colonial townships for Jewish people planted on occupied Palestinian land), a new legal strand emerged and standard Israeli law was selectively and exclusively applied to the Jewish residents of the West Bank and the Gaza Strip. Such were the emerging features of a regime that has gained increasingly unfavourable comparisons to apartheid rule in South Africa. In Israel and the territories under its control, legal restrictions on people are conditional upon identities and the respective status of these identities within heavily stratified and discriminatory

laws. The regime, in other words, implements a "legally sanctioned separation based on discrimination."[17]

The so-called Six-Day War of 1967 resulted in the expulsion of another 300,000 Palestinians from their homes, including 130,000 who were displaced for a second time after their initial displacement in 1948.[18] The defeat followed by the military occupation shattered Palestinians' hopes for return, but energized the national movements led by the *Fedayeen*. To pacify resistance in the Strip, then Israeli Defence Minister Sharon initiated a policy of home demolitions that continues to this day. As people in Gaza were subjected to intensified restrictions on freedom of movement and to increasingly squalid economic conditions, it was no accident that the 1987 *Intifada* was first triggered in Gaza, specifically in the Jabalia refugee camp, and rapidly spread across the remainder of the Strip before it was joined by the West Bank. The uprising was a mass popular movement that held up for six years. It manifested in protests and strikes, in civil disobedience, and in boycotts. Unable to supress the masses, Israel shut down Gaza's universities for six years, denying tens of thousands of students the opportunity to study, including one of the editors of this series. It imposed curfews locking the entire Palestinian population of Gaza inside their homes every night for about six years.[19] An order ascribed to Israel's then Defence Minister, Yitzhak Rabin, directed the Israeli army to break the bones of Palestinian protesters.[20] The images of unarmed Palestinian youths throwing rocks at fully armed Israeli troops captured attention in international media and contributed to a narrative of the Palestinian David fighting Israel's Goliath.

Amidst the heat of the *Intifada*, a peace process was launched in Madrid under the auspices of the Americans and

the Soviets in 1991. The process eventually culminated with the Oslo Accords, signed by Israel and the PLO on the White House lawn in September 1993. In keeping with the terms of the Accords, the Palestinian Authority (PA), an interim self-governing body, was constituted. The PA, led by the late Yasser Arafat, along with the PLO leadership, were allowed to return to Gaza and establish a headquarters. The Oslo Accords were the pinnacle of Palestinian hopes for statehood and self-determination. Widespread discussions stated that Gaza would become the "Singapore of the Middle East."[21] These hopes evaporated, however, when the Accords panned out as the "biggest hoax of the century."[22] They neglected to deal with the core issues of both the conflict and the Palestinian cause: with the Palestinian refugees, with the right of their return, and with the 1948 *Nakba*.[23] Reflecting his deep frustration at the aftermath of the Oslo Accords, Palestinian historian Salman Abu Sitta, himself a refugee expelled to Gaza along with his family, wrote to PLO leader Yasser Arafat, asking him why the Accords and his ensuing speech at the UN had omitted "Palestine," "Palestinians," and demands for inalienable rights:

> *I wished to hear you, Mr. President, say in your speech:*
> *I stand before you today to remind you that forty-six years*
> *ago 85 percent of my people were uprooted by the force of*
> *arms and the horror of massacres, from their ancestral*
> *homes. My people were dispersed to the four corners of the*
> *earth. Yet we did not forget our homeland for one minute...*
> *Let us learn the lesson of history: Injustice will not last.*
> *Justice must be done.*[24]

"Oslo," as the Accords are commonly called, entrenched the segregation of Palestinian communities. In 1994, a fence

was erected around Gaza; a permit system was applied to anyone who needed to leave the Strip. This had a drastic impact on the population's ability to conduct anything approximating a "normal" life, while severely weakening the Strip's economy.

The failure of Oslo to recognize the core issues at stake for the Palestinian people was followed by the breakdown of negotiations between the PA and Israel in late 2000. This stalemate provided fertile ground for the eruption of the second *Intifada*. Israel's violence in suppressing this uprising unleashed the full might of the world's fifth largest army against a defenceless civilian population. Daily bombings by F-16 fighter jets became the soundtrack of daily life in Gaza, while Palestinians mounted armed attacks against Israeli military posts inside the Strip and against the army and sometimes civilians in Israeli towns and cities.

In 2001, Sharon declared war on the PA's leadership, security officials, and infrastructure. Israeli bulldozers destroyed the runway of Gaza International Airport, attacked the symbols of Arafat's authority, and bombarded and destroyed Arafat helicopters. These attacks left much of Gaza's internationally funded infrastructure in ruins.[25] Even worse, however, as a form of collective punishment of Gazans, Israel imposed a policy of internal "closure," preventing movement within the tiny Strip. It divided the Gaza Strip into three parts. The principal closure points were on the coastal road to the west of the Netzarim colony (formerly located between Gaza City and the Nuseirat camp) and at the Abu Holi Checkpoint (named after the farmer whose land was confiscated to build the checkpoint), located at the centre of the Strip. Each time the Israeli army shut down these points, Gaza was split apart, paralyzing all movement of people and goods.[26] For five consecutive years, for Gazan

doctors, nurses, patients, students, teachers, farmers, labourers, and mothers, a trip from north to south—ordinarily a ninety-minute round trip—could turn into a week-long ordeal and dependence on the kindness of one's extended family for accommodations and food until the checkpoints were reopened.[27]

In 2004, Dov Weisglass, adviser to Prime Minister Sharon, declared his strategy of rendering the peace process moribund and his intention to sink it, along with Palestinians' national dreams, in "formaldehyde."[28]

Israeli political activity has always been rooted in unilateralism. The false narrative of a "land without people" permitted the "people without a land"—now instated in what was formerly Palestine—to conduct themselves in absolute disregard of the existence of another people. The latter, like so many rocks and boulders, were simply to be bulldozed flat as the new state was being constructed. Israel's unilateral disengagement from Gaza in 2005, vacating about eight thousand settlers whose houses and farms covered forty percent of the area of the Strip, was an act of political sleight of hand that allowed Israel to declare itself free of political and moral responsibility for the Gaza Strip, while also declaring it an "enemy entity" in 2007.[29] It could accordingly be enveloped in a siege designed to generate medieval living conditions.[30]

The 2006 free and fair elections that brought the Islamic resistance movement, Hamas, into power were the fruit created by Israel's departure, viewed by many Palestinians as a victory of the resistance, led by Hamas, to Israel's brutal policies of oppression, as well as to the inherent weakness at the heart of the PA. The latter, which is supposedly authorized to govern, is constrained by severe limitations that

effectively disable the centrifugal forces allowing the governance of states. The US and the EU were the parties at whose demand the fledgling PA conducted elections, and these were declared fair and free by all international monitors. And yet, these same parties proceeded to boycott the results (which they found unsatisfactory) and to cut foreign aid to the PA. For the most part, these cuts and the shortages they incurred were imposed upon Gaza (and to a lesser degree, the West Bank).

Declaring Gaza an "enemy entity" allowed Israel to conduct four major offensives against the Strip, in 2008, 2012, 2014, and 2021. The 2014 offensive, which lasted 51 days, destroyed much of what had previously functioned as Gaza's infrastructure and institutions, including the complete or partial destruction of at least 100,000 homes, 62 hospitals, 278 mosques, and 220 schools.[31] It also left 2,300 people dead, the majority of these being civilians, and tens of thousands wounded.[32]

Four generations of refugees now live in the Gaza Strip, scattered among eight refugee camps. As of 2023, Gaza is still under siege. Access to the outside world is controlled by Israel or by Egypt, acting as Israel's subcontractor. No one can enter or leave the Strip without permits from one of these two powers. According to the UN Office for Coordination of Humanitarian Affairs, in 2022, 1.3 million Palestinians in Gaza lacked sufficient food for their families and required some sort of humanitarian assistance.[33] Food insecurity has reached 64 percent.[34] Unemployment, measured at 47 percent in 2022, is among the highest in the world.[35] Economist Sara Roy has characterized the pattern as one of structural de-development, and Israeli historian Avi Shlaim describes it as "a uniquely cruel case of

intentional de-development" and a "classic case of colonial exploitation in the post-colonial era."[36] Although the World Bank has said that Gaza's economy is in "free fall," the Strip has in fact maintained a perverse stasis: formaldehyde, after all, is used to preserve corpses.[37]

Israeli sociologist Eva Illouz compared the present circumstances of the Palestinian people to conditions of slavery. These conditions, she said, present one of the great moral questions of our time and are similar, in certain respects, to the slavery that embroiled the US in civil war in the nineteenth century.[38]

The strands of oppression and violence running through the Palestinian tapestry are interwoven with strands of endurance, ability to overcome, and *Sumud*—steadfastness—in the face of injustice. Palestinians still firmly believe in return and in the possibility of justice, even if these ideals have become embattled and tattered. Gaza's high level of concentration on the importance of these narratives belies its tiny size, at just 1.3 percent of historic Palestine. Protesting the circumstances of all Palestinians, the near suffocation of the Gaza Strip, and the international disinterest in both, Gazan civil society launched the Great March of Return in 2018. Weekly protests were initiated along the border fence with Israel every Friday, calling on both Israel and the world to recognize the inalienable right of Palestinians to return to the homes and lands from which they were forcibly removed seven decades ago. The protesters also insist upon a plethora of other basic rights denied to Palestinian people in the "ongoing *Nakba*" of their lives.[39] The World Health Organization reported over 300 Gazans were shot and killed by the Israeli army in the course of these rallies as of December 2019, with 35,000 more

injured.[40] On May 14, 2019, alone, Israeli military snipers killed 60 unarmed demonstrators and wounded more than 2,700.[41]

The weekly marches are an ongoing journey fulfilling the prophesy of Mahmoud Darwish that "a stone from our land builds the ceiling of our sky."[42] Every independent state formed after "the dismantling of the classical empires in the post-World War Two years" has recognized an urgent need "to narrate its own history, as much as possible free of the biases and misrepresentations of that history," as written by colonial historians.[43] In an analogy to the poetry that represents a highly important oral tradition in the Arab world, we see this book as an effort to capture the poetry of life and the history of a people, expressed by those who live it on a daily basis.

Filling In a Tapestry of Resistance Through Memory Work

The history of Gaza is far richer and deeper than the standard narratives of helplessness, humanitarian disaster, or war story would have us believe. Moreover, as is the case with other post-colonial regions and their histories, Gazan history differs greatly from official accounts and Eurocentric renderings based (largely) on oversimplifications.[44] This series is, accordingly, an attempt to replace detached— and sometimes questionable—statistics and chronologies of erupting conflict with some of the concrete details of actual survival and resistance, complex human emotions, and specific difficult choices. The stories recounted reflect crucial facts and important events through the evidence of lived experience. They contextualize selective reports and statistics, correcting omissions, misrepresentations, and misinterpretations.

This series is an attempt to reimagine the history of Gaza from the viewpoint of its people. A true understanding of Gaza entails a reading of the human history beyond and behind chronologies, a reading that follows some of the coloured threads that make its tapestry so vibrant. The seven women whose stories we relate communicate the history they lived, through reflecting on events they experienced in their own voices and vocabularies. They shared feelings and named processes as they understood them, enabling others to grasp and realize the sheer dimensions of the injustice to which they were subjected and which they amazingly withstood.

Israeli New Historian Ilan Pappe has used the term "memoricide" to denote the attempted annihilation of memory, particularly that of the Palestinian *Nakba*. A systematic "erasure of the history of one people in order to write that of another people's over it" has constituted the continuous imposition of a Zionist layer and of nationalized Israeli patterns over everything Palestinian.[45] This has included the erasure of all traces of the Palestinian people— of the recultivation and renaming of Palestinian sites and villages. These practices were recounted victoriously by Moshe Dayan in 1969:

> *We came to this country which was already populated by Arabs and we are establishing a Hebrew, that is, a Jewish state here. Jewish villages were built in the places of Arab villages and I do not know even the names of these Arab villages, and I do not blame you, because the geography books no longer exist, the Arab villages are not there either. Nahalal arose in the place of Mahlul, Kibbutz Gvat in the place of Jibta; Kibbutz Sarid in the place of Huneidi*

and Kfar Yehushua in the place of Tal al Shuman. There is not a single place built in this country that did not have a former Arab population.[46]

In the context of daily hardship, then, memory is crucial. It is a deeply significant site for resisting policies of elimination and erasure. Often, such resistance work takes place within families, and, in particular, through women. Stories of lost homes are handed down from generation to generation and repeated time and again, preserving the names of lost villages and towns, detailing former landholdings, passing on deeds, and recounting traditions and tales about "the ancestors, everyday life, the harvests, and even quarrels."[47] When asked where they are from, most of the children of Palestinian refugee families will state the name of a village lost generations ago.

In recognizing women's diverse experiences as a key to decoding history, we share accounts of women of the generation that experienced the 1948 *Nakba*, told with the backdrop of the master narratives of Gaza, offering new insights into the story of Palestine. The respective narrators enable readers to gain a fuller understanding of the scale of tragedy experienced by each of these women and of its socioeconomic and political impacts.

The series draws on the concept of "history from below" proposed by the French historian Georges Lefebvre, who emphasized that history is shaped by ordinary people, over extended periods of time.[48] It also draws on the feminist concept of "herstory," where feminist historians and activists reclaim and retell the suppressed accounts of historical periods as women, particularly marginalized women, experienced them. It is in these traditions that we present the

oral histories of Palestinian women from the Gaza Strip. The school of oral history, initiated with tape recorders in the 1940s, achieved increased recognition during the 1960s, and is now considered a major component of historical research that enlists the assistance of twenty-first-century digital technologies.[49] In defending the method of recording oral history, Paul Thompson argued, in *The Voice of the Past: Oral History*, that it transmutes the content of history "by shifting the focus and opening new areas of inquiry, by challenging some of the assumptions and accepting judgment of historians, by bringing recognition to substantial groups of people who had been ignored."[50] The historically "silent" or more accurately "silenced" social groups cited by Thompson include Indigenous people, refugees, migrants, colonized peoples, those of subaltern categories, and minorities. Such groups have employed the methodology of oral history to represent the totality of truth and to counteract dominant discourses that suppress their versions of history. Moreover, oral history has been recognized by these groups as a method of realizing their right to own and sound a voice, to write their own history and share their collective experiences, and to resist the dominant colonial rhetoric that omits or obliterates these experiences. In this context, Alistair Thomson argued that "for many oral historians, recording experiences which have been ignored in history and involving people in exploring and making their own histories, continue to be primary justifications for the use of oral history."[51]

Oral history, as a method that both enhances and disrupts formal history, has not yet taken root extensively in the Arab world. Among a few rare exceptions, according to anthropologist and historian Rosemary Sayigh, are the Palestinians "who have used oral and visual documents to

record experiences of colonialist dispossession and violence that challenge dominant Zionist and Western versions of their history."[52] In gradually moving "from the margins to the center," this practice has come to constitute the core of Palestinian historiography in the past twenty years,[53] and is deployed abundantly, both formally and informally, in collecting and reviving knowledge that was formerly unrecorded. In response to Edward Said's call for the "permission to narrate,"[54] oral history has paved the way for the continued production of archival collections, resisting the ongoing erasure of Palestinian spaces, existence, culture, history, and identity. Sherna Gluck notes that this method not only recovers and preserves the past through the collection of accounts, for example, of the *Nakba*, but also establishes the legitimacy of claim and of the right of return.[55] For Palestinians such as Malaka Shwaikh, a Gaza-born scholar, oral history and memory of the past act "as a force in maintaining and reproducing their rights as the sole owners of Palestine" and as "fuel for their survival."[56]

Over the past two decades, numerous laypeople, non-governmental organizations, and solidarity workers have joined the intellectual mission of rescuing a history that aims, according Said, to advance human freedom, rights, and knowledge.[57] That mission has gathered momentum and gained significance in historic Palestine in a context of neglect on the part of the Palestinian national leadership, which has failed to organize and ensure continuous records or documentation of popular Palestinian experience and of the ongoing dangers posed by the Israeli occupation.[58] The specifics of this violence as a current historical process were highlighted in a book by Nahla Abdo and Nur Masalha titled *An Oral History of the Palestinian Nakba* (2018). The

book includes a detailed discussion of the potential of oral history for historicizing marginal experience. It also notes that Palestinian history has not been adequately recorded as the experience of both a community and individuals, and emphasizes the vital role that oral history plays in assembling the Palestinian narrative.

The role of Palestine during World War II features prominently in standard historiographies, but little has been written about its Indigenous population, the conditions of their existence prior to 1948, or their collective life and history before exile. Summing up this gaping void, Said wrote: "Unlike other people who suffered from a colonial experience, the Palestinians...have been excluded; denied the right to have a history of their own...When you continually hear people say: 'Well, who are you anyway?' you have to keep asserting the fact that you do have a history, however uninteresting it may appear to the very sophisticated world."[59]

Scholarly Work on Palestine's History

Many historians and researchers have drawn on both oral and visual history to counter the multiform suppression and abandonment—ranging from disinterest to fundamental denial—of Palestinian history recounted from Palestinian standpoints. A variety of strategies have been adopted in carrying out such work, and among these efforts are Ibrahim Abu Jaber et al.'s *Jurh Al Nakba* (The wound of the *Nakba*) (2003) and Walid Khalidi's *Before Their Diaspora: A Photographic History of the Palestinians, 1876-1948* (1984). Others have presented individualized narratives, for example, Salman Abu Sitta's *Mapping My Return: A Palestinian Memoir* (2016), Alex Awad's *Palestinian Memoires: The Story of*

Palestinian Mother and Her People (2008) and Laila El-Haddad's *Gaza Mom: Palestine, Politics, Parenting, and Everything In Between* (2010). Scholars such as Ramzy Baroud, in *Searching Jenin: Eyewitness Accounts of the Israeli Invasion 2002* (2003), have used oral testimonies in more comprehensive works to gain a fuller understanding of specific events (in this case, Israel's siege on Jenin in 2002), while linking the event in question to collective Palestinian history. Others have recounted the singular history of specific political factions, for instance, Khaled Hroub in *Hamas: Political Thought and Practice* (2000), Bassam Abu Sharif in *Arafat and the Dream of Palestine: An Insider's Account* (2009), and Nabil Amr in *Yasser Arafat and the Madness of Geography* (2012). Several online projects and websites, such as *Palestine Remembered*, have also initiated and continue to maintain an ongoing collection and dissemination of Palestinian oral histories.[60]

Nakba: Palestine, 1948, and the Claims of Memory (2007), edited by Ahmad H. Sa'di and Lila Abu-Lughod, is one of the more prominent attempts to incorporate oral history as an essential means of delivering history, justice, and legitimacy for the Palestinian cause, while also linking current events to the recent past. Departing from the *Nakba* as a central event that defines and unites Palestinians, their volume undertakes the injection of collective memory into the overall framework of Palestinian history. Making memory public, Sa'di and Abu-Lughod write, "affirms identity, tames traumas and asserts Palestinian political and moral claims to justice, redress and the right of return."[61] It also challenges the Zionist myth that Palestinians have no roots in the land.

Some authors have taken up Said's idea of the intellectual's mission being to advance human freedom and knowledge.[62] This idea is based on Said's definition of the

intellectual as being both detached and involved—outside of society and its institutions, and simultaneously a member of society who is constantly agitating against the status quo. Ramzy Baroud's book *My Father Was a Freedom Fighter: Gaza's Untold Story* (2010); the Indigenous section in Ghada Ageel's edited volume *Apartheid in Palestine: Hard Laws and Harder Experiences* (2016), which includes chapters by Reem Skeik, Samar El Bekai, and Ramzy Baroud; Palestinian poet Mourid Barghouti's *I Was Born There, I Was Born Here* (2012); and Mowafa Said Househ's *Under the Nakba Tree* (2022) are all manifestations of a concept in which the outsider is also the insider, the researcher, and the narrator. The authors of these narratives either spent a large part of their lives under Israel's occupation or returned from exile to live or visit, and they experienced the suffering of both the individual and the group. These experiences generated their common aspiration to become intellectuals who would repeatedly disturb and problematize the status quo. In documenting their personal stories and describing everyday life in the West Bank and Gaza, these insider-outsider-researcher-narrators have attempted to link present and past.

Within the broader context of abandoned and suppressed narratives, accounts of women's experiences, elided almost completely from hegemonic histories, open sorely neglected but significant avenues into an understanding of how the past and the present are constituted, reconstituted, and conceived. Women's accounts are particularly vital for comprehending the past and present in Palestine, as they are framed and determined by the ethnic cleansing of 1948. While women's stories are largely marginalized, their experiences form a cornerstone of the structure of human impacts generated by successive military campaigns against

Palestinians and by generations of Palestinian resistance, both military and non-violent. Foregrounding women's narratives counteracts a history in which selectiveness reinforces and supports systems of oppression and displacement through the erasure of authentic voices and the prioritization of male-dominant narratives.

The tragedy of 1948 and its aftermath in Palestine have been endured by the whole of society and particularly by women, who have borne the remnants with which to reconstruct lost homes both on their backs and in their hearts. As they have put up and organized tents to house their families, they have cared for and raised children, and queued for hours to receive United Nations rations and handouts of clothes, blankets, and kitchen utensils. They have struggled to keep smiles on their own faces and those of their families in the face of humiliation and bitter pain, in the day-to-day practice of what Palestinians call *Sumud*. Uncovering the details of their life journeys under such exceptional circumstances reveals a version of Palestinian history that is not only far more complete, but that also acknowledges the central role that women have played in making this history. Sayigh has argued that

> *women have been a basic element in the Palestinian capacity to survive poverty, oppression, exile. They have been models of courage, tenacity, resourcefulness and humour. Though all were victims of expulsion and of gender subalternity, I would never think of them primarily in these terms, but rather as people who knew/know how to live against poverty and oppression. Palestinian women have the inner resources to make a good life for their*

children. They pack, and move, and set up again in a new
place, among new people.[63]

Research on the role of gender in preserving the memory
of the *Nakba* has been carried out by several scholars who
have attempted to detail and highlight this crucial agency. In
their contribution to *Nakba*, edited by Sa'di and Abu-Lughod,
Isabelle Humphries and Laleh Khalili used oral history to
"examine both how the Nakba is remembered by women,
and what women remember about it."[64] It was also crucial
to them to investigate how women's memories "were imbri-
cated by both the nationalist discourse and the same
patriarchal values and practices that also shape men's lives
and their memories."[65] Their chapter confronts the manifold
predominant narrative and the resulting lack of confidence
that has suppressed women's voices and constrained their
role as a conduit of memory.[66] Palestinian women's lack of
self-confidence vis-à-vis, and exacerbated by, the male-dom-
inant narrative is clearly reflected, for instance, in Sayigh's
quotation from one female narrator: "I can't say I know all
this history; others know it better." While this narrator is
an articulate "history teller," she still designates the task for
telling history to those "who would know better."[67]

Fatma Kassem's book *Palestinian Women: Narrative*
Histories and Gender Memory (2011) focuses on Palestinian
women living in Israel. Kassem collected the oral testimo-
nies of urban Palestinian women, a group whose life stories
of displacement are rarely noted, even though they form
essential parts of the larger Palestinian national narra-
tive. Kassem, who was born in today's Israel years after the
Nakba, positions herself as both an insider—a narrator of her
own story—and an outsider—a researcher—in the volume

that aims to reveal "the complex intersections of gender, history, memory, nationalism and citizenship in a situation of ongoing colonization and violent conflict between Palestinians and the Zionist State of Israel."[68] Like Baroud, Ageel, and Barghouti, this positionality allowed her a great deal of freedom in crossing boundaries as an unconstrained outsider while interacting intensively as a trusted insider with the other narrators.

The work of Sayigh exhibits a similar type of direct interaction with the narratives of Palestinian women. She has authored several books examining the oral history of the Palestinians, notably, *The Palestinians: From Peasants to Revolutionaries* (1979). In her work *Voices: Palestinian Women Narrate Displacement*, an online book, Sayigh narrates the stories of seventy Palestinian women from various locations in the West Bank, the Gaza Strip, and Jerusalem.[69] The interviewees speak about their lives following the displacement of Palestinians after the *Nakba*. Like most of her influential work, Sayigh's interviews—conducted between 1998 and 2000, just prior to the initiation of this project—investigate displacement and its effects on Palestinian women, and the impact of the *Nakba* on the identity of women. Also considered in her book is the linkage between collective displacement and the crucial role played by women in the Palestinian narrative. Sayigh's body of work not only advances the destabilization of dominant narratives, it also accurately situates Palestinian women and their voices at the heart of Palestinian history, offering a fuller, more inclusive and comprehensive understanding of Palestinian history.

The Women's Voices from Gaza series, which includes this volume, is a continuation of the oral history work carried out by many intellectuals and individuals who aimed to

assign Indigenous Palestinians a greater role in explaining the dynamics of their own history and to reorient the story of Palestine by restoring it to its original narrator: the Palestinians. It is a complement to a corpus of work that preceded this series and that asserts the centrality of the narrative of Palestinians, especially women, in reclaiming and contextualizing their history.

Come My Children

Come My Children is the third in this series of seven stories collected in the late 2000s and recounting life in Palestine prior to and after its destruction. It is the tale of a native Palestinian Christian from Gaza City. Her name is Hekmat Al-Taweel.

In her story, Hekmat unlocks the door and invites readers to the inside world of Palestinian Christians, an integral part of Palestinian society constituting about 10 per cent of the total population in historic Palestine in 1948.[70] Over the past seven decades, that percentage has steadily and radically declined to less than 2 percent.[71] According to the Palestinian Central Bureau of Statistics, the number of Palestinian Christians who live in West Bank and Gaza Strip is around 47,000.[72] A very small fraction of this number, about 1,100 people, live in the impoverished and besieged Gaza Strip.[73] This steep decline in population is due to multiple and complicated political, economic, security, and religious factors.[74] Some reports suggest that the Christian Palestinian population is declining because of a rise in religious intolerance on the part of the Palestinian Authority, particularly since the eruption of the second *Intifada* in 2000,[75] but the bulk of the research in this area suggests otherwise. Most studies show that the demographic crisis is

mainly due to a long history of dispossession caused by the *Nakba* of 1948, the expulsions of 1967, the Israeli policies of collective punishment, and a general lack of freedom and safety. It is also a direct result of the Israeli occupation and its policies of denial and discrimination that hit Palestinian Christians in general, and those living in Jerusalem and Bethlehem in particular, hard.[76] The decline of the Christian population in Bethlehem (Jesus's birth city) from 86% Christians in 1948 to 12% in 2016 is a case in point. The construction of the illegal Israeli separation barrier, also called the apartheid wall, segregated the city and its inhabitants from Jerusalem and the rest of the West Bank. This has had a devastating impact on Bethlehem's population forcing large numbers to leave their historic city.[77] Describing the destructive effect the wall has had on the people, the Open Bethlehem organization stated, "With the land isolated by the Wall, annexed for settlements, and closed under various pretexts, only 13% of the Bethlehem district is available for Palestinian use."[78]

Hekmat's story affirms this position, and refutes allegations that Muslims are to blame for the Christian decline or that this decline is the result of a Christian-Muslim struggle. Weaving together many narrative threads, her story unearths a version of history long excluded from mainstream discourse, providing a fresh look at native Palestinian Christians in the political, historical, and religious domains and illuminating a vibrant life and culture, strong and rich community relations, old traditions, and powerful resistance against colonial invasion.

In her narrative, Hekmat, a daughter of one of Gaza's prominent merchants, reveals an unknown and unfamiliar perspective on Muslim-Christian relationships: one of

harmony, of mutual understanding, of respect, and of unity. This mutual relationship of unity and harmony has been confirmed by the Palestinian Catholic priest of Gaza, Manuel Musallam. Musallam, in response to Israeli attacks on Jerusalem, stated that "Christians will defend Al-Aqsa Mosque and Muslims will defend the Church of Holy Sepulchre," and vowed that Palestinian Christians "will die strong" with their heads up "around Al-Aqsa Mosque and the Church of Holy Sepulchre in Jerusalem's Old City."[79] Hekmat's narrative fills in the details of this unity and resistance as well as the details of daily life, showing that both Muslims and Christians honour each other's celebrations, rituals, and events, and exchanged Palestinian traditional dishes such as *borbara* and *sumaqiya* prepared on special occasions. But more than sharing food and occasions, Palestinian Muslims and Christians share the same history, customs, and traditions because they "belong to the same nation and same culture."[80]

This robust sense of belonging is why Hekmat, at the end of her story, turns down her husband's family's invitation to live with them in the United States. "I can't leave Gaza," she says. "I want to stay in my city and my homeland with my people and die and get buried here."

Married to a Gazan merchant, Elias Al Sayigh, Hekmat travelled all across mandatory Palestine, visiting cities that had been considered the hubs of Palestinian culture and the heart of the Palestinian economy such as Haifa, Jaffa, Jerusalem, Nazareth, and Tel Aviv, and went abroad to Egypt, Jordan, and to the United States. Her many trips to metropolitan centres like Jaffa exposed Hekmat to different lifestyles and ways of doing things. It opened her eyes to the beauty, variety, richness, and modernity of Palestinian life

and culture beyond her own community. Each time she returned to Gaza, Hekmat shared her newfound knowledge of fashion, styles, and haircuts with Gazan women. The demand on her expertise became so great that she opened a beauty salon in her home in Gaza, one of the earliest of its kind. She later pursued an advanced training course in sewing, which eventually led to her becoming one of the most popular dressmakers in Gaza.

Like the other narrators in this series, Hekmat witnessed some of the most turbulent periods of Palestine's modern history. She was born under the British Mandate and lived to witness the consequences of the destruction of Palestine and the dispossession of its people after the 1948 Nakba. She also witnessed Egypt's defeat in 1967, followed by Israel's military occupation of the remnants of historic Palestine, including the Gaza Strip. When the first *Intifada* erupted in 1987, Hekmat, like many of her fellow Palestinians, felt a renewed hope for liberation, justice, and an independent Palestinian state. Although this period culminated in the Oslo Accords, the peace and justice these accords promised has yet to reach Gaza. The second *Intifada*, also called *Al Aqsa Intifada*, broke out in 2000.

Hekmat's narrative is unique in its detailed portrayal of the rich tapestry of Palestinian daily life and relations during and after the British mandate in Palestine, a perspective that has often been neglected in histories and narratives that tend to focus on the political clashes between Palestinians and the British, and later the Zionists. Hekmat's story depicts critical features of Palestinian society that readers rarely encounter, providing a meticulous picture of ordinary Palestinian Christian family life in the early twentieth century. Her story spans her childhood and early adulthood

and portrays her strong but humorous character, great social skills, and special love of the English language. The proximity of her family home to the Baptist Hospital in Gaza's Old City, where many foreigners have worked and lived, provided her exposure to different cultures and traditions. More than an individual account of life under complex political upheavals and wars, Hekmat's narrative preserves minute details of distinctly Palestinian collective life and history through different eras and regimes. Her descriptions of the aspirations, pursuit of education after marriage, voluntary work, and activism of Palestinian women, herself and others, conjure a picture that contradicts Western, orientalized stereotypes of Arab women. Her story demonstrates the capacities, agencies, and ambitions of Palestinian women, and the obstacles they struggle against, including patriarchal social constraints similar to those faced by many women around the world.

Like the other stories that comprise this series, Hekmat's narrative goes on to capture the disruption and crippling changes the 1948 *Nakba* caused in Palestinian society. Hekmat highlights these still-unfolding changes in telling about her voluntary work with the Women's Union, the Palestinian Red Crescent Society, and the Women's Empowerment Society, organizations that were established to aid with the influx of refugees—more than triple the pre-1948 population of Gaza—who sought sanctuary in her city. Hekmat's story conveys the Palestinian displacement and dispossession with great clarity, contradicting the infamous Zionist myth that Palestine is a land without a people unproblematically awaiting a people without a land, and revealing the depth of the solidarity between native Gazans and their displaced Palestinian brothers and sisters.

The experiences that surface in her narrative highlight the role played by Palestinian civil society in mitigating the national tragedy of the *Nakba*, uncover solid community relations, and underline women's central roles in these efforts—aspects that are largely missing from stories told about Gaza.

Following the *Nakba*, Hekmat's story describes life under the Egyptian administration of Gaza (1948-1967), including the benefits that Palestinians enjoyed during this time, especially the free education that enabled her to study at the English department of the Egyptian Popular University campus in Gaza. She also touches on some of the tensions that Palestinians had with the Egyptian government, not least because of its support for the Johnson proposal, which called for the resettlement of Palestinian refugees in the Sinai Peninsula.

When the 1967 war erupted, Hekmat and her family found shelter in the church beside their home. When the war ended, Gaza was under Israeli military occupation and Hekmat's family experienced a very difficult time marked by strict curfews, routine arrests, and loss of lives and livelihoods. The story goes on to shed a bright light on Palestinian dreams and yearning to go home. In the early 1970s, Hekmat and her husband Elias travelled to Jaffa to visit the houses of his two brothers, seizing the opportunity that Israel offered Palestinians to visit the homes and lands from which they have been expelled. When they arrived, they found the houses occupied by illegal Jewish settlers who claimed rights to the properties, one of which had been turned into a kindergarten. In her revealing and painful recollection of the visit, Hekmat narrates the details of a conversation, or rather confrontation, with the Jewish settler who denied

them access to the home-turned-kindergarten. While they argue, Hekmat barges into the home, pointing out a painting by Elias's niece, Emma, that was still hanging in the living room, her signature etched into the corner of the canvas. When they leave, Elias, heartbroken, bursts into tears and says, "Look Hekmat, my brother's home which he built from his blood has become a kindergarten. I can't imagine that these strangers who have no right to be here are living in my brother's home, and preventing us from visiting it. If Hanna saw this, I am sure he would not be able to withstand this theft. He might even die."

Though childless themselves, Hekmat and Elias always loved children, and this love prompted them to raise their Muslim neighbour's son, Yusuf, as their own. When he was young, the boy moved back and forth between his birth family's home and that of Elias and Hekmat. When Elias died during the first *Intifada* in 1987, Yusuf chose to move in with Hekmat and live with her permanently. Hekmat reflects on her life during the *Intifada*, another difficult time with more curfews, demonstrations, arrests, and home searches. Before his death, Elias, by then a sick old man, was interrogated by Israeli soldiers, and Yusuf barely escaped arrest. Hekmat's chief concern during this time, besides her work as a sewing teacher and supervisor at the Council of Churches, was trying to survive with Yusuf, then a teenager, while assisting her community against the dangers and harm of military occupation.

During the second *Intifada*, which erupted in late 2000 after the failure of the peace process, Hekmat shares her exhaustion from the years of wars, attacks, invasions, assassinations, and demolitions. She expresses her dream for a lasting peace in Palestine, one that is based on justice and

the restoration of Palestinian rights. These rights, in Hekmat's view, must include a sovereign Palestinian state and an end to both the military occupation and Israeli colonization of Palestine:

> *I will never trust any agreement, or say peace is coming, until I see it with my own eyes. Many peace agreements have been signed but the promised peace has not come. The agreements remained only on paper, like the countless* UN *resolutions on Palestine that sit on the shelf collecting dust. The only time I will believe there is peace is when I see calm, the end of occupation, and the return of the* muhajreen *to their homes. I will never believe the news about peace on the radio and television until we feel this peace in our lives, peace that ensures and fulfills our rights and dignity and gives us an independent state.*

Sadly, peace did not come in her lifetime. In 2008, at the age of 90, Hekmat did, indeed, die peacefully in Gaza among her family and her people and was buried in her own land.

Come
My
Children

1 / Childhood

Growing Up in Gaza

Palestinian Christians and Muslims have similar customs and traditions. We also have very good and very strong relations with each other. If our Muslim neighbours cooked a meal they sent some to us, and if they bought something good and cheap they told us where to go and buy it. We shared each other's happy and sad occasions. For example: if we had a happy occasion, such as a wedding, during a sad occasion for them, such as a death, we delayed [the wedding] until their mourning period had finished, and then we celebrated. They also did the same.

I AM ROMAN ORTHODOX, like my family and my husband's family. My father from his father, and his father from his father. It is the pure Christianity where the prayers, traditions, and customs are unchanged from generation to generation; nothing has changed. Orthodox means "the straight way"; it is very old with very genuine and pure principles that haven't changed for a long time. We are different from Latin and Baptists, a little closer to the Catholics, but still there are many differences in the prayers, customs, and many other things. We don't follow the Pope in Rome, like the Catholics and the Latin sects do. We have a Greek

Patriarch in Jerusalem and he is the head of the church. I go to our church every Sunday here in Gaza, and after Sunday service I sometimes go to the cemetery to pray and ask for forgiveness and mercy for my husband, my parents, and family members. There was only one Sunday I didn't go to prayer, and that day I fell on the stairs; thank *Allah* I wasn't hurt, but when I think back to that instance, I believe I fell because I didn't go to church that day.[1]

Fasting is an important pillar in our religion. When we fast, we can eat tomatoes, okra, squash, lentils, beans, *hommus*, and all kinds of fruits and vegetables, but not meat or any animal products such as eggs, cheese, yogourt, or fish. Now we are in the time of Our Lady Maryam the Virgin who gave birth to Christ, and we call this the Virgin's fast, so we fast for fourteen days. We eat on the fifteenth, her feast day, the day she died. We are allowed to eat fish on two days of this fast. We have a forty-day fast for the birth of Christ, and another forty-eight-day fast, the big fast, when the Christ was crucified, suffered, died, and then was resurrected. So we have two feasts: one that we call the small feast, when Christ was born, and the big feast at Easter after his resurrection. Christmas Day is the last day of the year and then we celebrate the new year about two weeks later. Our Muslim neighbours used to ask us to tell them the fasting days so they could fast with us because it is mentioned in their Book, the Holy Quran, as in our Book, the Bible. So we told them and they fasted. We also fast Wednesdays and Fridays of every

> Top: *The interior of Hekmat's church.*

> Bottom: *Hekmat's church and its cemetery in Al Zaitoon.*

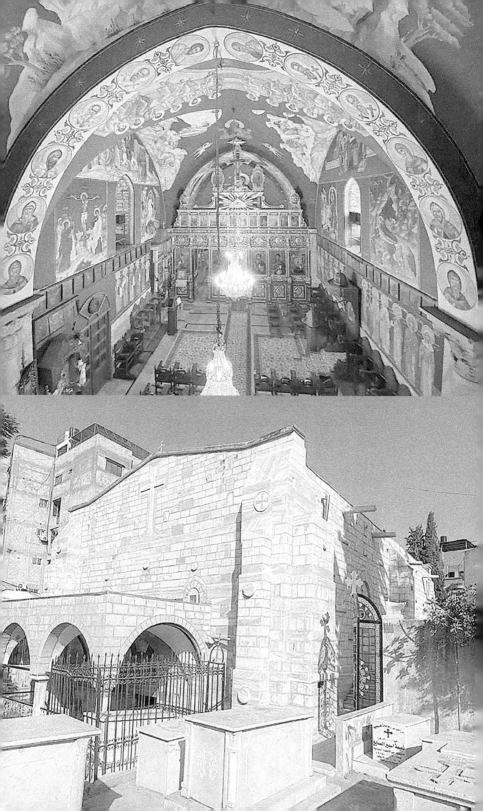

week, although sometimes there are feasts on these days so we are allowed to eat. Nowadays not many people fast.

My parents married in 1918 and lived happily together, and in 1922, the year that Palestine was placed under the British Mandate, I was born. Three years later, when my mother was about twenty-five years old, my sister Maroom was born. My mother was so sad and cried a lot when she gave birth to her as she had lost two boys before she had me, so she expected a boy, but this didn't happen. In this regard, Christians and Muslims have similar customs here in Gaza; they prefer boys to girls, and although things have started to change these days, society in general still prefers male children over female children.

When my sister was only two weeks old, my mother died from puerperal fever. This was widespread among women who gave birth and there wasn't any treatment at that time, so sadly whoever contracted puerperal fever died. Many doctors came to check my mother; as one went, another came, and as they met they whispered to each other that it was hopeless. Even the Church Mission Society's doctors couldn't help.[2] My mother's family also knew this, and I remember the women from our family as well as friends wringing their arms and asking how she could die so young, *haram*. They were very sad. None of them told my mother but [I know] she knew she was dying because I was told by her family that my mother used to say, "Who will take care of my daughters? Who will take care of my baby after I die?" She cried all the time, and my father and all my mother's relatives cried as well. Puerperal fever at that time meant death but now there is treatment. I wished it had been discovered at the time of my mother's death so she could have survived and we could have had a mother to talk to and

be with, to care for, love, and shelter us, because nobody can replace a mother or a father. I still find it too difficult not to cry when I meet orphans and there are many as you know because of the occupation. To comfort myself I always say that this is the choice of *Allah* and we must accept that.

Although his brothers urged him to remarry, start a new life and raise us, my father refused and didn't listen. He always sobbed when this matter was raised because he loved my mother very much and was devastated and in a state of shock after her death for a long time. My father cried a lot after my mother passed away, and later developed heart problems. You know, he used to stare at me for a long time, and when I asked him why he used to say, "Because you are very similar to your mother. When I look at you I feel better, and I feel that I can see your mother in you." I used to be happy when I would hear this as I was taking it as a complement, but now after I lost my husband, I understand the sheer pain that my dad had for losing my mother.

My mother's family also used to look at me and say, "We can see your mother in you. You are an identical replica of her." I was much loved in my mother's family home and was spoiled by the family and by everyone else because my mother died when I was so young. My grandfather and uncle from my mother's side took me by the hand to many places. They encouraged and loved me very much, especially my grandfather, who contracted an eye disease and became blind. I remember when he put me on his knee facing him, I would tell him, "You are not blind; I think you are lying because your eyes are wide open staring at me now. Don't you see me? I think you are a liar. Look! You are watching me."

"I wish I could see you because I am told that you look like your mother."

"So look at me and see me." Then I would raise my hand and tell him to count my fingers. By accident he once said five, so I said, "See, I know you are a liar. How do you know there are five?" He laughed when I said this and told me I was clever.

One of my uncles travelled a lot and always bought me gifts when he returned to Gaza. He went by train to Egypt, Syria, Lebanon, and Jordan, as the borders were open, not like today, and when he saw a child-sized mannequin in a shop, he bought the whole outfit if he thought it was my size: shoes, socks, hat, dress. He took everything. I always counted what he had brought me and would say, "Oh, you brought me four pieces and last time you brought six. Why did you bring me fewer pieces this time? I am a bit frustrated. I still love you but not as I used to the last time." So he would then give me money as a way of reconciling with me. Every day he bought me candies. The other girls in our house, including my sister Maroom, were jealous because I had everything and always told them what my uncle had brought me this time, with all the details. Everyone always waited for the feast days or Christmas to see what I would wear, and many of Gaza's famous dressmakers would too, so they could take note of the pattern of my dresses.

At Christmas we would cook a sheep, or pigeons filled with rice and herbs, and prepared a very big table for all the family. We received many toys, and I always asked my father what he was going to bring me. And he would always say, "A dress." So I would say, "No, my uncle will bring me a dress, so bring me shoes," or whatever I wanted.

The feast was a happy time, and we used to wait and count the days until it came. During the feasts we greeted and kissed our old relatives' and parents' hands and were

given money. We prayed in the church at Christmas and also at the big feast of Easter, when we received eggs.

In front of the Orthodox church was the Orthodox Club, and it consisted of two or three rooms and a hall, and in front a big area to play basketball and volleyball. After prayers people met there for a cup of coffee and chatted away while the young people practised playing sports and football. Only boys played [sports] in the club because it was still a conservative society. Different teams played against each other. We would root for a team and when they won we were very happy.

We lived in the Old City of Gaza, the suburb of Al Zaitoon close to the Gaza Baptist Hospital, which was then known as the Church Mission Society Hospital, although people used to call it the English Hospital because it was easier to say. The hospital, which is now called the Ahli Arab, was also known as the Sterling Hospital, after the English doctor who founded and managed it for about two decades.[3] There were two main hospitals: the Church Mission Society and the municipal hospital, which was situated on the present municipal building site.

We used to go to the CMS Hospital because it provided better services and had a pharmacy underneath, and after we saw the doctor we went there directly for medicine. The English prayed at the CMS Hospital, which had a church inside as well as a school and a cemetery. It is a very old hospital where many English and foreigners were employed, and foreigners still work there. They still work with the same system as before—the English system—and it is clean, well maintained, and organized; different from other local hospitals here. There are three floors: one is for clinics and hospital purposes, the second is a residence for the hospital's

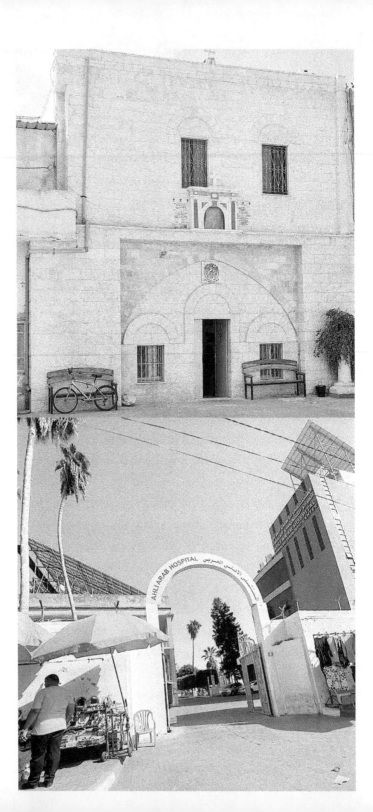

A stairway down to the CMS Hospital.

< *Top: The Church Mission Society (CMS).*

< *Bottom: Entrance to the CMS Hospital (called the Ahli Arab
Hospital today).*

foreign employees, and the third is a residence for other foreigners. There was a great English doctor who lived there. He was called Dr. Hargreaves. His home is still there but is now part of the hospital. We used to play with his children and they also came to our home and played with us. The English children studied in the English schools in Jerusalem and came to Gaza for their summer holidays, and this is when we played with them and they came to eat with us. It was a happy time when they visited us as we played together and went to each other's homes.

We used to go with my father to the market, helping him to carry the vegetables and fruit in a basket. We weren't allowed to go alone to the market, which was huge, so we always went along with my father. A small grocery shop close to our home sold candies, sugar, tea, juice, cigarettes, soap, and things like this, but not vegetables or fruits because they were only sold in the market. We used to go to Al Daraj to buy things that weren't in our area, like material and fabric to make clothes, and when I said I wanted to go there, my father always told me to take someone or a group of older girls with me. For us, in those older times, Al Daraj was like another country, and it was the same if someone from Al Daraj wanted to come to Al Zaitoon. They were always asked where they were going and told to take someone with them. But not alone; we were never allowed as young girls to go alone.

We visited the Al-Barbari family in Al Daraj, where my friend Yusra Al-Barbari lived.[4] Yusra later became a leading figure in our community and the head of the General Union of Palestinian Women. We were the same age and she was in my class, so we were friends. I was also friend with her sisters and many girls from Al Daraj. We played when the families visited each other and I used to be very delighted

when there was an event at their home and we would get to visit them, or when they would visit us.

There were good seamstresses at that time who made our clothes. We went with other girls and women to choose material from Al Daraj. Sometimes people sold different kinds of material from their donkey carts, going from house to house. My older cousins sewed for us, so everything was done at our home. In the afternoons and during the summer vacations our families sent us to dressmakers in our neighbourhood to learn to sew, so we would learn some basic skills instead of always playing in the streets. We did simple things like tacking the patterns before they were sewn, and removing the tacking after they were sewn by hand-powered machine, and sometimes there was nothing to do so we played hopscotch instead or played with the young children while their mothers finished their work.

We played different games: skipping, hopscotch, *'arayis* [bride dolls], and brides. We chose a bride from amongst ourselves and would pull her skirt down until it reached the ground, and covered her stomach where the skirt had been with a long *shash*, and wrapped it around while leaving some fabric to make a train on the ground behind her. We put a veil on her head and she sat on a chair while we danced and sang in front of her. It was exactly the same as a real wedding party, with ululating, playing the drums, and everything else we would do at a Palestinian wedding. When our families heard us, they always said, "Our girls have a wedding today." We made *'arayis* ourselves by wrapping cotton thread around two sticks of wood in the shape of a cross. We wrapped extra cotton around the top of one of the sticks to make the head, and then covered all the body with the same cotton, and made clothes for her.

One year, locusts attacked Gaza and we saw very big, dark clouds covering the sky from the west to the east, making a large shadow that hid the sun. When some fell, we picked them up and played with them and then killed them. After that year we didn't see locusts again.

I spent most of my life in Al Zaitoon, the oldest and largest neighbourhood in Gaza City, and know every street and corner there. I know all the families and when I pass I can name all those living in those houses. I like going to the Old City very much because I enjoyed living there and have many good memories and many good friends. We had good neighbours and very good relationships with them. We would exchange many things, everything, with each other and we would also send each other traditional Palestinian dishes like *borbara* and *sumaqiya* and visit quite often. One day we might visit a sick friend or neighbour, or a lady who had a baby, a couple who recently married, or a family having an event, and the next week or the week after that, those people would return the visit and come to our home to visit us. We also regularly exchanged dishes of food with each other, sharing our recipes and any cooking experiences and expertise with one another. We still keep this tradition, although it is much less common here in Rimal where I currently live compared to Al Daraj and Al Zaitoon.

Palestinian Christians and Muslims have similar customs and traditions. We also have very good and very strong relations with each other. If our Muslim neighbours cooked a meal they sent some to us, and if they bought something good and cheap they told us where to go and buy it. We shared each other's happy and sad occasions. For example: if we had a happy occasion, such as a wedding, during a sad occasion for them, such as a death, we delayed [the

wedding] until their mourning period had finished, and then we celebrated. They also did the same. During Ramadan a cannon on the hill in Shuja'yya was fired at the end of each day of the fast so they knew when to break the fast and eat, and when we were children we went with our Muslim neighbours' children to wait for the cannon to fire. Then we cheered happily and everyone went home singing. We celebrated their *'Eid Al Fitr* that marks the end of the month of Ramadan and wished them happy *'Eid*, and they celebrated our feasts with us and wished us happy feast as well. We sent dishes of *borbara*, a traditional Gaza dessert dish, to all our friends and neighbours. We cooked a very big pot and kept two big dishes for us and gave the rest to them, and did the same with our *ka'k*, and in return they sent us dishes of *sumaqiya* and *ka'k* in a very close and understanding relationship.

My mother once breastfed a boy from a Muslim family so, according to Islamic *Shari'a* [law], we became brother and sister. My mother was also breastfed by a Muslim mother, and her baby was breastfed by my grandmother. When my grandmother wanted to visit someone or go shopping and didn't want to take my mother, she used to leave her with this family, and when she was hungry this Muslim neighbour breastfed her because she had a son the same age. And it was the same when this neighbour wanted to go somewhere without her son; she gave him to my grandmother who breastfed him when he was hungry. This happened many times. I used to call him my uncle, and when people heard this, they said, "Uncle? But he is a Muslim and you are a Christian, how can he be your uncle?" and I would explain to them.

My father had two brothers: one had died at an early age and the other lived with us. The one who had died had

three daughters: two were married, and the other raised us. She cooked, took care of us, and raised us. Her sisters were married and lived in Beersheba, not far away from Gaza, and we visited them and spent happy days there. We brought special things from Gaza that they didn't have in Beersheba and when they visited they brought things not found in Gaza. After I was married, my cousin's older sister took her to Beersheba where she married a man from Jerusalem. She later moved to Jerusalem where she had a daughter who sadly died.

My uncle who lived with us had three boys and three girls, and we were two girls and my cousin. There were three rooms in our house: one for my uncle, one for us, and the third for guests, where my male cousins slept. My uncle's room was the biggest and had domes and arches, with the other two rooms on either side. Upstairs were two big, open rooms covered by palm fronds—one for us and one for my uncle—and also a space to hang clothes. There was a big, wide-open area in front of the rooms where we prepared food, like chopping *molokhia* or drying fruits and vegetables like okra, tomatoes, corn, and figs because it was a sunny place. And in one small area we grew pomegranate and olive trees. We had two taps at our home, one in the kitchen and one outside, and we always had water, which was a blessing as some people in other places in Gaza had to fill water containers to have water. A man would come on a donkey selling sweet water for drinking or making tea, and juice, and we would buy it and keep it in big and small pottery jars so the water would stay cold. We could drink from the taps but the water we bought was sweeter, and if it ran out we cleaned the empty jars and filled them with tap water and drank it, but we didn't drink the water at the very bottom because it

was not fresh or clear. We made dough for our bread at home and either took it to the neighbourhood baker's oven to be baked or sometimes a boy came to collect the dough and took it to the bakery, and we paid him with *qersh* [1/100 of a Palestinian pound] or a *malleem* [1/10 of a *qersh*] depending on the quantity of bread.

We had a big table that we ate and studied at. We put a kerosene lamp on it and my friends came to do their homework and study with me because we had a big area, a big table, and good light. We used kerosene lamps, one in the kitchen and another outside. We studied during the weekends, which were Fridays and Sundays. Relatives in the neighbourhood helped me with my lessons because I didn't have older brothers or sisters or a mother. Their mother was a very sweet Lebanese lady and cared a lot about me. She helped me the same as my uncle's wife who lived with us. I really appreciated their help in raising me and my sister, as well as my father's niece who also had a role in raising us. Later we sold the houses that belonged to my father and uncle and my husband. They were then demolished and people built new houses where our homes used to be.

At the southern entrance to Gaza, downhill from Al Zaitoon, was the area called Al 'Awameed [the columns], named for the rows of ancient stone columns there, with the names of some of the martyrs who fell while defending our homeland written on them. They probably date back to the Mamluk time.[5] There were four or five huge and very beautiful white marble columns, with a dry cistern in the middle. It hadn't been used for a long, long time but was very sturdily built. The place was shady with nice breezes, and it was cool because of the marble. People sat there and chatted, and sometimes if a woman wanted to go for quick

shop or to stop by somewhere for a moment and she had a baby, she put her sleeping child in the cistern and asked the women sitting in the area to take care of the child when he or she woke up. That was normal in those days with no possibility of danger because most people knew each other. I was shocked a few years ago when I visited the area and didn't find any columns; all of them were gone but the name of the area remains as well as its good memories.

My father was a big merchant and every summer he erected a big tent at Al 'Awameed, and there he waited for people who came from the southern areas of Deir Al Balah or Khan Younis to sell their harvest and crops. He used to buy wheat, barley, corn, and sesame from them. So these farmers, or sometimes other merchants, preferred to sell to my father rather than climbing the hill and searching for other merchants. They sold him all they had for one or two *qersh* less than what they sold to the merchants in town. My father weighed the crops in their sacks and then they emptied the sacks and took them on the backs of their camels or donkeys because this was the means of transportation then. Then people came to buy from my father. My father worked here all through the summer and I remember the large quantities of these different crops became like hills the size of this room, and I used to go with my sister Maroom and play there, trying to climb the hills or pushing the grain down with our hands. My father would become angry and tell me to take my sister and go home, but I didn't care and continued playing.

During the winter my father had two coffee shops where he employed two men to make coffee and tea. One shop was in the Orthodox Club and the other in Al Saraya, not where it is now; there were government offices in front of where

Al Zahra School is currently located.[6] The employees of the British administration bought tea and coffee from this shop during their working hours.

2 / The British Mandate and School Days

THE HEAD OF THE POLICE in Gaza was Mr. Redding, who was in Gaza until 1947. When he and his family first came, they lived for a short time on the third floor of the CMS Hospital private residence and then moved to a bigger house close to Al Zahra School, on the border of Shuja'yya. We were friends with his children and used to play together, girls with girls and boys with boys, at his home, and they also came to our home. They didn't speak Arabic, only English, and we didn't speak English at that time, only a few words like "yes," "no," "hello," "wait," "come here," "goodbye," "thank you," my name, my age, "what is this," "I like this," "I don't like that." But we understood each other and used sign language to explain ourselves. People didn't like the English in political terms but some, especially the wealthy, had business with them, and even became friends with them. I remember my family and other adults told us not to speak with them about people or the news of the area because they might go and tell their father. So whenever they asked a question we knew was about something happening we always pretended not to understand, or said we didn't know. We only talked about eating, drinking, and playing. I remember

his daughter was my age and her name was Mary. We used to play together and practice English, and I asked her to correct me if I made any mistakes. So she was my friend, but she was also the daughter of the police chief, and although we loved each other I didn't treat her like other girls because I knew her father imprisoned and probably tortured people.

The English had a big centre in Gaza next to Al Zahra School. Once while I was playing hopscotch with Mr. Redding's children and my friends beside this centre, I heard someone calling me from a small window. This was a prisoner that the British had arrested and brought to this prison. Later I discovered he was a leader of the *Fedayeen* [freedom fighters] whom the British had moved from prison to prison; I think he was in Jerusalem, then Jaffa, and then Gaza. He was from the Sourani family and everyone knew him because he was active in the national movement against the English and their polices in Palestine. He had waited until the English girl had moved away so she wouldn't hear, and chose me from among the other girls. He looked from the very small window and said, "Hey, girl, are you the one called Hekmat?"

I said, "Yes."

He asked me about the name of my family and I told him, and he asked about a man and I told him he was my uncle, so he said, "Do you know the Sourani house?"

I said, "Yes, I know," because I played there with their children. He told me to go and tell them that he was here, and gave me his name, but not to tell anybody [else] about what he had told me or I would be put in jail. I was very afraid of being put in that scary and closed place. He told me to go straightaway, and quickly, so I left the girls and went to the Sourani house and asked for the girl I played with. When

she came out I told her, "Your uncle is in Gaza prison. Go and tell your father."

But she said, "No, he is in Jerusalem prison, not here."

I said, "This is what you know, but the fact is that he is in Gaza prison," and I told her the story.

She went to tell her father, who quickly came and asked me to repeat the story to him, so I did, and then other men from the family came and again I repeated the story. Then I left to continue playing with my friends. A short time later I heard a very big demonstration coming, with demonstrators chanting and demanding the release of this *Feda'i*. The English went crazy because they didn't know how people had found out that he was in Gaza, and stopped the demonstration by shooting live bullets in the air, and the demonstrators scattered. Then they started searching for the demonstrators. They arrested many people and asked why they had participated in the demonstration, and how they had found out, but nobody knew; they only heard people say that this *Feda'i* was in Gaza. Nobody thought about me.

When I returned home my father asked me why I was late and I told him the story at once. He asked me to eat my dinner quickly in case the English soldiers came to arrest me because I was the one who had told about the *Feda'i* from the Sourani family. I didn't know whether he was serious or not but I didn't worry much because I was very young, though I was afraid of the idea of being detained and put in jail. My father also told me not to tell anyone. And yes, we didn't tell anyone and kept the secret. Even my relatives and cousins wondered who leaked the information about the where-abouts of that *Feda'i* but they never knew. People said that when he was in Jaffa prison nobody knew, and when he was

in Jerusalem prison nobody knew, but when he was in Gaza prison everyone knew, and nobody knew why. And I kept silent and looked at them, even though deep in my heart I wanted to tell them proudly that I was the one, because I was still afraid that if I opened my mouth I would be imprisoned as my father warned me. This man was moved to another prison and before the British left he was released, after being imprisoned for a long time.

When I was very young, I participated in many demonstrations against the unjust English rule and their colonization of our land. The earliest I remember was a huge demonstration in 1929. In that demonstration I carried the Quran in my hand and a Muslim girl of my age carried a Bible, and we were carried on the shoulders of two men who led the crowed. I didn't exactly understand the reason for that particular demonstration, but later when I grew up I learned that it was against the execution of three famous *Fedayeen* whom the British hanged in Acre.[1] In that demonstration, I dropped the Quran because I was very excited and wasn't carrying it properly. When some people gave it back to me to carry, they were very angry and asked me to hold it tight, and if it were dropped again another girl would replace me. I did not like the idea of another girl replacing me so I held the Quran tight until the end of the demonstration. One day at the end of the 1920s, probably when I was five or six, a demonstrator told me to say that I would spit on British soldiers for their persecution of our people, and then to pretend to spit. I repeated what he said to a British soldier who was standing on the side of the road with his rifle, and he came and patted my shoulder and said, "You are a nice baby." I didn't understand what he had said and when I was asked later, I thought it was something like *"bis bis,"* the

sound we make when we call a cat, or *"nis bis,"* and they [the demonstrators from the neighbourhood] laughed at me, and told me what he had said. Had I been a bit older [and could] understand what the soldier said to me I would have told him that we are very nice people but they are the ones who force us to behave otherwise because of their policies in our land.

Later I participated in several demonstrations against the English rule and policies when I was at school. They were organized by young students and activists, and they used to tell us when we went to school whether there would be a demonstration that day or the next. Sometimes we went in the morning and sometimes after school finished, but we usually avoided the days we had examinations. We carried books, banners, and flags and walked from Shuja'yya to Gaza's municipality building chanting: "Down, down English! Down, down colonization!" When we reached the municipality building the English shot in the air to prevent us going any further, but after the municipality building there was nothing but sand, so it was the end of the demonstration anyway.

We escaped when the English soldiers tried to arrest us, and ran home using other shortcut roads that were different from the route of the demonstration. I remember once a demonstrator was shot and killed in one of the demonstrations against the English. He was leading the demonstration, and when the English started shooting in the air, a bullet hit him in the chest. I think he was the only one hit and killed in Gaza by the English in a demonstration, as far as I know. I remember a group of demonstrators took him to hospital while the rest continued chanting, but scattered when they reached the municipality building. I was young at the time

and at school. All these demonstrations were against the English, their rule in Palestine, and their unjust policies which suppressed the Palestinian national movement and supported the Zionist Jews who came from everywhere in the world taking over our land.

Yusra Al-Barbari, a national leading figure then, was a student at my school and we used to organize demonstrations against the British. And I remember once we went all the way to the CMS Hospital chanting, "Palestine is an Arab land, from water to water," and "Down, down English rule!" We also chanted, "Palestine calls: 'Come my children, come and protect land and honour!'"[2] We always chanted the same national slogans in the demonstrations for Palestine. They were long slogans, but I have forgotten the rest.

I studied until the seventh grade at Al Zahra School, which was then known as the government school, and it was the highest level of education in Gaza at that time. You know, we studied until the sixth grade, and when I was in the last year they added the seventh grade, which was equal to the eleventh grade of today. There was also the municipality school where students studied until the fourth grade, and then moved to the government school until the seventh grade. More grades were added a few years after I graduated. We had a beautiful school uniform of dark blue and white stripes, and a sport's uniform of a white blouse and dark blue skirt for physical education, basketball, and volleyball. I was very good at basketball and played, even after I was married, with the employees of the Baptist Hospital, who called me when they played.

Schools were segregated; female teachers taught at the girls' school while male teachers taught at the boys' school, and a male inspector was not allowed to enter a female

Al Zahra School in Gaza City.

teacher's class alone, but had to be with the female prin-
cipal. Some of our teachers were local and others came from
different places in Palestine to work in Gaza. They came
from Jaffa, Jerusalem, Nazareth, and other places, and female
teachers who worked in Gaza brought their mothers, sisters,
or brothers and rented a house, and then left to join their
families for the winter and summer school vacations. A few
years ago, I went to visit my teacher in Nazareth because she
was my favourite teacher whom I loved very much. When I
arrived I was told by her next-door neighbour that she had
died a month before, and they asked me who I was. When I
told them my name, they said that my teacher remembered
me and often spoke about me. In fact she had wanted me to
marry her husband's nephew so we could be together. When
she was a teacher, she came to Gaza with her sister and lived
in our neighbourhood. My family used to visit them and

send them food, especially when we cooked some special dishes, and always asked if they needed any help.

It was a happy time when we were at school. We celebrated and made cakes for each other's birthdays. One brought eggs, another flour, and we made it in one of our houses. Sometimes we made a good cake and sometimes a bad one, but we didn't care because the idea was just to have a cake for the birthday. So we met and took it as a surprise to our friend who was having the birthday.

I had a strong character, and wasn't shy when I was a child, so I was always taken to speak when visitors came to the church, the club, or the school. We had many foreign visitors, and I still remember two distinguished British visitors who came to the Orthodox Club, and then went to the municipality school. When the first one came to the Orthodox Club, I was wearing my school uniform and was given a bouquet and told what to say to welcome him. So I held the bouquet and said, "On behalf of the ladies of Gaza I give you this bouquet in appreciation of your services." He was very happy and kissed me and sat me on his knee, and whenever someone came to take me he told them to let me stay. When he left he held my hand, and when I was close to my home I left him. After he left, all my friends in the neighbourhood laughed at me and said, "Hey you, the one who was kissed by the English man." The next day he visited the municipality school and suggested they change their uniform to my school's uniform because he liked it very much. Later, when his brother came to visit Gaza, he said he wanted to meet the girl who gave the bouquet to his brother. So I went and welcomed him.

The English came to the school to make sure that the teachers were following the curriculum and instructions,

and especially to oversee the English lessons, and sometimes they attended parties or special events at the school. The teachers used to pick the students who were clever in English to speak to them and I was always chosen, and I also showed them around the school. Miss Helen Ridler, the inspector of all the girls' schools in Palestine, also visited us. She was in charge of interviewing teachers for positions in the schools, and could transfer teachers from school to school. She also chose girls to go to the teachers' training school in Ramallah, and also met families to convince them to send their children to continue their studies outside Gaza. She was a good lady and respected by people.[3]

Once, the headmistress called me after she noticed that my grades in English were way better than my grades in Arabic and asked me, "Is your father English?" And I answered no.

"Is your mother English?" And I answered no.

"Then, why are you better in English than Arabic? You should study Arabic like you do English," and she hit my hands with a ruler. I cried, and Miss Ridler saw me crying, and I told her the full story. Later in the day my father was told by one of our teachers who lives near us that Miss Ridler met the headmistress and told her that she shouldn't punish students because languages were a gift from God, and some children were good at mathematics, others at Arabic, and Hekmat was good and talented at English. The headmistress told her that she wanted to encourage me to study Arabic so it would be as good as my English, because I was excellent in English.

Miss Ridler also told me that I should study Arabic like I studied English because Arabic was important and my mother tongue. I told her, "But I love English very much,

more than Arabic and more than anything else!" And when she asked me why, I cried. I said, "I cry because I love the English language!" And she laughed. She used to call me whenever she visited the school to speak to me and was very happy with my level of English. I really liked the English language: the teacher, the books, the homework, and even the exams. It was my favourite class and my favourite subject. Now whenever I hear English spoken, I always say, "Because of my love for you, English, I was beaten in school." I was only ever beaten once at school, and that was because of English.

I remember a missionary called Miss Evans who worked at the CMS Church and used to visit the houses and speak to people, Christians and Muslims, about religion.[4] She used to come to our home to read and explain the verses of the Bible, and we used to listen to her out of respect but never followed what she said because she was from a different sect. She used to take me with her when she went to visit the houses to speak about Christianity, or visit in general, because I knew good English, and although she understood a lot, she spoke little Arabic. On Sundays we went to a small school she had at the CMS Hospital where she taught English. A neighbour taught mathematics, and my cousin taught Arabic there, and we went to practise English. I was young, maybe twelve or younger. My cousin was also a member of several women's associations of that time, doing voluntary work, and there were courses in handwriting, sewing, embroidery and other domestic sciences offered to women and girls. They had exhibitions and displays to show and sell what they produced, and made money for the associations and some-times for its members. My cousin was paid in Miss Evans's school, and Miss Evans was paid for her work too.

A guard at Miss Evans's house once found a young baby under a tree, and she [Miss Evans] adopted her, raised her, and educated her. When she [the child] started school, Miss Evans took her to England during the vacations. She got her a Palestinian birth certificate and a Palestinian passport issued by the British Mandate authorities. We were young and we used to wonder how a small girl has a passport, as travel was not as common in those days, especially for young kids who rarely travelled outside Gaza. Miss Evans always asked us to bring some of our food for this girl, saying that she was Palestinian and should know and taste Arabic food, the food of her people. Then this girl's father tried to see her, and to attract her he brought balloons and candies, which she sometimes took, and started to come to the house to see her secretly. When he came a lot and the girl realized he was trying to take her out of the house, she told Miss Evans, who sent the girl to England, and she never returned. When the father came to ask about her and told Miss Evans that he was the girl's father, she shouted at him and said, "Now you remember that you have a daughter and want her, while before you didn't! If you really cared for her, why did you throw her away and why didn't you marry her mother who had to throw away her at birth?" I always wonder about that girl found in our neighbourhood and wish I could know what had happened to her.

We also practised English with Mrs. Hargreaves, the wife of an English missionary doctor at the CMS Hospital.[5] She used to gather us one day a week and told us not to speak Arabic at all, only to speak English, and when we made mistakes she corrected them. Then she would ask us how to cook a Palestinian dish and we told her in English and she

helped us with the words. So she learned how to cook the dish and we learned English.

When we asked my father to take us out, he usually took us to the area called Safiat Al Haj 'Ali [Al Haj 'Ali hill], beside Al Saraya now, where there were big hills of clean, soft and white sand. We took fruit and played there, or sometimes we rested there and then continued to the beach. We also went there sometimes with an adult, taking nuts and fruit with us and something to sit on, and played and jumped and ran up and down the hills. We used to sit on a piece of plastic and slide down the hills. We sometimes used to roll our bodies down the hills and see who would reach the bottom first. We enjoyed the place and the breeze and had lots of fun but always needed to have a bath after we got back home as our hair and body were full of sand. After the hills but far from the beach were different kinds of trees like mulberry and almond, and lentils as well. We used to go and pick the trees and run for it, escaping before the owner saw us. We used to go there by foot, by bus, or by donkey and cart. On the way, there was a very large sweet-water well situated at the end of what is now 'Omar Al Mukhtar Street[6] where people used to fill their bottles or containers with sweet water. If we heard that someone was going to the well, we always gave him our containers to fill.

During the summer vacations my father bought a donkey to go to the sea and Safiat Al Haj 'Ali, and for trips around Gaza. For long distances we went by horse and cart. The cart was covered with an umbrella and we sat on benches to go visit our relatives who lived on the main road to Khan Younis. Buses took people to the beach and other places in Gaza, and we paid one *qersh* each way.

We practically lived at the seaside throughout the summer vacation as we always used to beg and say to my father, "Take us [to the seaside], summer is coming."

And he used to say, "If you study well and get high marks I will take you, but if you don't, I will not." So we studied very, very hard in the month before the exams, and when we received our certificates, we showed our father and told him to take us. We used to go with my uncles from my mother's side and neighbours. We prepared our clothes and food while the adults took wood, nails, and hammers to make shelters to sit and sleep in. They made three rooms from wooden frames, with coloured straw mats for the walls: one room to sleep in, one with carpets and mattresses for men and male guests, and a small place for the kitchen. They also made a very small toilet far from the rooms. When we finished building these three rooms, we helped our uncles and the neighbours build theirs.

We took cooking pots and dishes and all the kitchen utensils and a table where we put the pots and a kerosene cooking plate. I remember saying to an older person in the family, "Please give me a cucumber," or "Please make me a sandwich," and they would make one for me because the table was high and I couldn't reach it.

We played on the beach and my uncle told us to find crabs from under the rocks in the sea, and we picked them up in a way that wouldn't hurt us, then broke off their claws and ate them. Now when my neighbours buy crabs, they are afraid and call me to break off their claws.

I like the beach and I enjoy swimming very much. My dad and uncles taught me how to swim when I was very young during the summer time. I used to swim on my back as the

waves carried me along. I also used to show the younger girls how to swim. Our neighbours used to tell their daughters, "Go swim with Hekmat. She can help you." We used to dig deep holes and bury our bodies underneath the sand. I used to let my friends do this for me and massage my body, and when they asked me to do the same, I would tell them, "I teach you how to swim." Beautiful days.

In the mornings my father went from the beach to his work, and he brought bread, vegetables, fruits, and other things we needed. We stayed there from the beginning until the end of the summer vacation, about three months, and sometimes the school had already reopened while we were still there. When we returned, we were very black, with our skin peeling from the sun. It was a very happy time, one of the best times in my life.

We used to celebrate the Al Montar feast and we always urged our families to take us there [to Al Montar].[7] We used to cry in order to make them feel bad if they delayed a day or so because it was so beautiful during that event. Many people came from outside Gaza, selling their goods and fruits. We bought sugar-cane juice, orange juice and other fruit juice, different kinds of sweets, candies, clothes, carpets—everything, and many other things. All sorts of shows, races, a circus, and competitions used to be held during the festival. There was something to enjoy for everyone, the old and the young. I liked the circus and especially the horse races the most. I also enjoyed the *dabkeh*, the [other] dances, and the different songs. And of course the food and the different kinds of desserts. Their taste is still in my mouth.

There was a tomb of a holy man in the Al Montar area and what I know of the story is that the Prophet Elijah came to offer good guidance to the residents of that area, and urged

them to worship *Allah*, but they didn't listen to him so he left and they didn't see him again. This is what I heard from the old people around me; it's not written in any books, but this is what people think. Our Muslim neighbours believe that a holy man called Mun came to Gaza and settled here. He helped people, and called on them to be good and to avoid wrong deeds, and offered good guidance. He also used to treat sick people and offer all sorts of guidance and advice for life problems. The story says that Mun was frustrated as people did not follow his teachings and therefore he fled [*tar*]. This is the reason that the place is called Tal Al Mun Tar [the hill of Mun, who fled]. A tomb was made where he used to sit and speak, and in time it became a place where people went with their sick children or family members to pray for their recovery. This is what I remember as a child.

We also used to go to Hamman Al Samra every Saturday.[8] It was very old, from the time before the Turks, and there was another nearby *hammam* called Al Mbasher, which was destroyed. And now there are shops in the area where it once stood. I think another *hammam* called Al Wazeer was in Al Daraj and it has been demolished as well. I went with my uncle's family, some neighbours, and sometimes with friends, and there were separate days for women and men. We took clean clothes, towels, soap, and a loofah in a bag, and went to the changing rooms and then the bath. Some people used a *boqja* [decorative bag] for the bath, usually made of velvet and covered with colourful silk embroidery. I always wondered about the word [*boqja*]: does it come from Turkish or English? It sounds like "bag" in English, so I assume it came from English. But people say it is a Turkish word.

Some women wore swimsuits, some shirts and shorts—it depended on the person—and children went without clothes.

The ladies in the bath used to chat and gossip together while they were bathing, laughing, and sitting. They enjoyed going to the bath because it was a social event where women could meet, speak, and relax together. We played in the water, jumped, threw water at each other while we laughed, and it was a lot of fun. Then we sat underneath the taps and I remember the adults washed our hair and bodies and then told us to sit under the taps, one cold and one hot. When we were finished, we went into another room to dress in our clean clothes, pay the money, and go home, spick and span, clean and fresh. It wasn't far from where we lived in Al Zaitoon so I would say that when we were children, we went almost every Saturday because on Sunday we went to church to pray so we should be clean the day before. But it depended on our families. If they wanted to go, we went with them because we couldn't go alone as they wouldn't allow children on their own. If they didn't go, we bathed at home. After I was married, I rarely went there. Sometimes I went, maybe three or four times a year with neighbours or friends, because you should go in a group to enjoy the bath while not alone. At that time everyone had a bath at home but before, when we were children, not everyone had a bath in their houses.

| There were lots of problems in 1936 and the schools in Palestine, including Gaza, were closed for about six months, so in 1937 we repeated the same grade and then I graduated from school.[9] Nineteen thirty-six was a year of demonstrations and general strikes that paralyzed life in Gaza. People were fed up with the English suppression and wanted them to leave and end their colonization of Palestine. Many people participated: boys and girls, men and women, Muslims and Christians, basically everyone was suffering in one way or another from their unjust policies and treatment.

Hamman Al Samra in Gaza's Old City.

My father was so attached to us that he didn't allow me to continue my studies outside of Gaza. Miss Ridler came to my home once or twice to see my father and ask his permission to allow me to study and to later teach English because I was very clever. She sat on a chair in front of him as he sat on the floor, with his *arqila* [water pipe] and coffee pot in front of him, and [she] asked, "Are you Hekmat's father?" And he answered yes.

She said, "We want to take Hekmat to study the English language because she is very smart. She could be the head of the English department and supervise schools in Palestine. I envision a good future for this young girl. We want to teach her at the women's teaching college in Ramallah. What do you think?"

My father looked at me for a while then looked at Miss Ridler and said, "I only have these two daughters and I can't be separated from them."

She said, "It won't be a long separation, only two years. In addition, you will not pay a penny; we will pay everything, and she will have a good job and a good future. Let her go."

But my father refused to let me study outside Gaza because he didn't want us to be separated, so I lost that opportunity. I got frustrated. I wished that he had accepted her request but unfortunately this didn't happen. He was so attached and afraid of something happening to us. I understood his fears and his love for us. And I myself wondered if I could bear being separated from my father for such a long period of time. Also, at that time people were still conservative and rigid-minded and not many boys and girls went outside Gaza to study, although some girls from Gaza went to Ramallah, Jerusalem, and even Cairo to pursue higher education. My friend Yusra Al-Barbari and her sisters did exactly that. Their family, who were Muslim, alongside other Muslim families, allowed their daughters to travel for education. Miss Ridler was very upset when my father refused to allow me to continue my studies. But in the end, this is *Allah*'s will and I understand the reasons behind my father's decision. This was the reason that I did not argue with him or even attempt to convince him. I knew he loved me and knew what was good for me. With the passage of time, I started to appreciate his sacrifice for me and my sister and to understand the pain he endured after the loss of my mother. It was enough for me to think that my presence at home was a comfort to him as he saw in me my mother's image. So I moved on.

3 / Marriage and Relations with Palestinian Muslims

THERE WERE DIFFERENT SOCIAL CLASSES of
Christian families, and their family names were very crucial
and so important, like in every Arab society. After all, we
are one society and one people. So, influential and wealthy
families married amongst themselves and less important
families married each other. If someone from an important
or high-status wealthy family married into a lower-status
or less important family, the gossip started: How did they
meet? Why did they marry? Did the parents really approve
of this? They shouldn't do this. But sometimes they said that
maybe they fell in love and this is why they married, so leave
them. This still happens now; the family name still holds
importance, like in many Arab societies.

My husband, Elias [Al Sayigh], got to know me through
his sister, my uncle's wife. He used to visit her because we
lived in the same house, so he used to see me, but I had
never spoken to him on my own because it was not allowed.
Yes, I opened the door and greeted him when he came to
our house to visit and I sometimes saw him when I used to
go with my uncle's wife when she visited her family, but not
more than that. He liked me and went to my father to ask for

my hand. My father told me that he was coming, and asked me my opinion and whether I liked him or not. I said I didn't know and that he could decide, and my father said, "I like him. He is a good and honest man and has good morals, but I do care about your opinion." So I told my father that since he liked him, I would like him too. And we became engaged.

We were engaged for more than a year and went out together before we were married, but always with a third person, never alone. We went to the beach by taxi or bus. There was a lot of sand in the area of Al Saraya and taxis usually had problems there so we would get out and continue on foot to the beach. On our way back, we went by taxi or bus, or walked and rested on the clean, soft, white sand. Now when I go to the area beside the municipality in 'Omar Al Mukhtar Street and look down and see all these houses and buildings next to each other, I can't believe that it was empty before. It was only sands then, nothing but clean sands [*rimal*]. This is the reason behind the name of this area, Rimal.

At night I usually go to sit and chat with my old neighbour, and I told her yesterday I wish that our fathers could come to life for one night and sit on this balcony and see how Gaza has changed over the past decades, especially the seaside. Look at the buildings, lights, hotels, houses; there is no beach or sand anymore. Life has changed very much between that time in the thirties and forties and now, and this is why I wish my father could come, for a night or even a couple of hours, to see the changes. I'm sure if he saw it, he would not believe it, and maybe he would prefer to stay in his grave than to have this hour of life. It was much more beautiful, pure, and safe then. Now everything is gone.

I was married at the end of 1938 when I was almost seventeen years old and my husband, Elias, was about thirty years

old. My father allowed me to marry early because I didn't have a mother and he wanted me to be protected and safe in my husband's house. When the wedding date was set, we prepared different invitation cards to the wedding reception, or the church, or both. At that time not many people printed cards, they mostly just sent someone from the family to knock on the doors of the neighbours and relatives and invite them in person. Usually this person was one of the family members of the bridegroom.

So we went to the church and the priest conducted the ceremony. We left the church by foot to my husband's house, which was very big, and on the way people stopped us and offered us drinks, different types of juice but in small amounts, until we arrived at the house, where we had a big party. Then there was supper on a big table arranged with different kinds of food side by side. I had a long, beautiful white dress and veil, and gloves, and a tiara on my head. I bought most of my wedding clothes in Tel Aviv and Jaffa, except the wedding dress. It was made in Gaza by a skillful dressmaker.

We lived with my husband's family: his mother, two of his brothers, and a widowed sister with her two daughters. The women cooked together and ate together, and sometimes Elias joined us at lunch, and sometimes not, depending on his work. So if he came, we ate together, if not I ate with the family. Water came [to our house] almost 24 hours a day, but we would fill up a tank in case it didn't come.[1] If we didn't need the water in the tank, we used it to wash the floors; we didn't let the water stay in the tank too long. Then we filled it again after we cleaned it. Even if there was no water for a few hours, it always came again so there was no shortage of water.

Our home was big, with six big rooms beside each other like the current schools, and a kitchen, and upstairs was a second floor with a very big guestroom for men, where my single brothers-in-law sometimes slept before they were married. After they were married, my husband and I slept there in the summer. It was like a big salon: very big, with many windows and a door. In front of the six rooms was a big space, which many people who don't have space in their own homes used for wedding parties. I loved this as we used to be invited and watched all the wedding parties in our neighbourhood, even from outside. The house was not far from my father's house. Most of the Christians used to live in that old area of Gaza. Many still live there, others moved to Rimal or outside Palestine. The situation became very hard on everyone after the 1967 occupation.

In our house there was a downstairs guestroom with a door leading to the garden, which had two lemon trees, many banana and olive trees, a fig tree, and an orange tree. In the middle of this garden was a fountain where we used to sit, and Elias also entertained his friends there or in the upstairs room. When men came to visit, Elias and his brothers sat beside the fountain to smoke *arqila* or cigarettes and drink coffee and tea, and the small drops of refreshing water fell on them. In summer when it was very hot, I used to put a hose on a banana tree and made a shower to cool off under the cold water. I showered with my clothes on because it was in the garden and not private. It was a big, beautiful house, and it is still there and registered in the Al Sayigh name. It's old now and nobody lives there, although neighbours go and collect the olives. But foreigners used to take photos of it. My brother-in-law later moved and built a new home, and we, too, bought a *dunum* [about a quarter acre] of land to build

our own house and leave the family. Elias was very hesitant to leave the house and the area but later changed his mind.

My husband was the oldest in his family and felt responsible for them. This is the tradition in Palestinian and Arab culture. He helped the whole family and considered their children as our children because we had none. Elias liked children very much and often gave them candies and money. A short time ago, a man told me that when he was young, he and other children used to wait for him. He [the man] said, "When we saw your husband, we told each other and waited on the corner of your street because we knew he would give us candies when he passed, and we knew when he came and went, and waited for him." I didn't know this. I knew he liked children, but he never told me he always gave candies to them. Now I know.

I loved the children of my sisters-in-law and considered them my own. I played with them, and when their mothers punished them, I stopped them and shouted at the children, and took them to my room and pretended that I would punish them there. Then I let them play inside for a while before letting them out to apologize to their mothers. My sisters-in-law respected me because I was the oldest so when I told them not to punish the children they stopped.

My husband's nephews and their friends came to our room to study, so I took our bed and temporarily put it in the guest room and moved a big table in there for them. Day and night they studied, and I helped them with their homework and lessons, especially during exams. I loved them very much and they were clever students, and now they remind me of this. Not everyone had a quiet room to study or electricity then, but we did, so they were able to study at night. During this period, we used to sleep on a mattress on the

floor until the end of exams. It was better than the hassle of moving the bed in and out our bedroom.

I had a good relationship with my mother-in-law, who at that time had authority in the house. All the daughters-in-law lived in the same house, and she was the one who decided many things. And we respected her. For instance, if I wanted to visit my family, I would ask her and she would say if I could go, or to postpone it until the next day if guests were coming and we would be busy. And if I told her I could go after the guests had left, she would say that if I wanted to enjoy my visit with my family, I should have enough time to see all of them. She used to say, "Stay today and go early tomorrow morning and spend the whole day and enjoy it with your family." But it wasn't a dictatorial relationship; it was more like advice, and we respected and accepted her opinions. Her daughter and daughters-in-law used to tell her that she loved me more than them, and told me the same thing. And yes, I felt that she loved me more than them because I was good to her and avoided making problems and didn't argue a lot. Elders in our culture are highly respected and we are taught from a very young age to respect the elders. Before my mother-in-law went anywhere, I used to stop her and arrange her veil in a nice way or pass her some nice hand cream to apply before she went, or some perfume, small things like that. And later, before she went anywhere, she would come to me and say, "Hekmat, what do you think? Shall I wear this dress or change to the other one? How about the veil? Does it match?"

When I visited my family, I went in the morning, had lunch and dinner, and at the end of the day Elias came and we stayed until ten or eleven o'clock and then went home. When I visited my family home, I went alone because it

wasn't far from our home, but if I wanted to go farther I took someone with me, like my sister-in-law or mother-in-law.

We went to a reception day every week, a sort of social gathering where we dressed well, met with friends, and sat and talked and laughed, and were offered light food and coffee. It was like a party. I remember I did this on Wednesdays. So women came to my house and with my mother-in-law and sisters-in-law I entertained them in the guest room. We used to go to Muntazah Al Baladiyah [Gaza's municipal park] every Wednesday because it was the day for women, and as it was the same day as the reception day, we divided into two groups; one went to the park and the other remained at home to receive the women.

We took food and went in groups to the park, and usually it was full of women enjoying themselves. You could hear the laughs coming from everywhere. If we were lucky, we found an enclosed place or shelter to sit and eat. These shelters were made of wood and had wooden benches inside attached to the walls, and a small table where we put our food. Women or girls at the next place came to see what we had, and we exchanged food with each other. It was great fun, especially when we gathered to tell stories or jokes. You know, if we knew a joke we used to keep it until Wednesday to have something to say. I was famous for telling jokes. Once I told a very good joke and the next day, while I was walking in the street, I heard a man telling it, and he stared at me and laughed. I became very angry and the next Wednesday when I went to the park and met his sister, I told her next time if I told a joke and she wanted to tell it to others, to please not mention my name, but just say that someone had told her. And I told her what had happened to me in the street and the girl apologized.

Our house was next to the CMS Hospital, and separated by a very low wall that we could jump over and speak to the doctors and nurses, many of whom were American and English. When we cooked *mahshi* [vegetables stuffed with rice, meat, and herbs], we called them and gave everyone a squash and eggplant or whatever vegetable we had, because they liked this dish very much. They even told us to tell them whenever we cooked *mahshi*, and when we called them from the wall, they would ask, "Is there *mahshi*?" and told each other, and were very happy and came and ate, and then left.

I think the CMS Hospital became known more as the Baptist Hospital at the end of the forties when Baptist missionaries came to Gaza with their ministers to attract people to their sect. These Baptists had money, and with it they built their church inside the hospital and then dominated the church and the hospital because they came from outside Palestine, mainly from Britain, and were richer than other religious sects who came here. They prayed differently from us and didn't allow Orthodox people to pray there until they were baptized or changed their religion to Baptist, and then they were accepted. We did not listen to them or follow their religion but kept ours.

I was good at English and liked to speak and practice it very much. I learned new words every day from speaking to the doctors and nurses at the Baptist Hospital, and sometimes I taught them some Arabic words. One day a nurse heard a sentence in Arabic, which she memorized and asked me the meaning of it. I asked her where she had heard it, and she said she had heard a teenager saying it to his sister, and she thought he must love her very much, as he was laughing with her. But I was shocked and told her that it wasn't like this; they were very bad words, and that she mustn't say

them in front of anyone or they would say that she was a very bad woman. Sometimes they called me to translate when they didn't know what people wanted. If someone visited a patient when it wasn't visiting hours, or couldn't understand the directions for their medication, I would go and explain to them, and in this way my English improved.

Elias had many friends, and he had a close Muslim friend in Shuja'yya who came to our home regularly and ate lunch with us, and we visited him. In fact, we had more Muslim friends than Christian, and I could say that sometimes this relationship was stronger because they didn't involve special interests; it was pure friendship. We had strong relationships with merchants and businessmen, and if some of the stock ran out, Elias's friends gave him what he needed to distribute to shops until his stock arrived. So they were like brothers, even stronger than that. I used to tell him that this was very rare even between families or with those from the same religion, and he used to say that Muslims didn't have special interests and were good friends. So thank *Allah* for this. They still phone and ask about me, and whether I need anything, and even when they slaughter sheep during their *'Eid Al Adha* days, they send some of the meat to me. Every *'Eid* I ask them why they are tiring themselves doing this, because they live far from where I live now, and they say, "This is our duty, whether you live in Al Zaitoon or on the moon." Nowadays you rarely find these very strong relationships between people, especially in the cities. Everyone is busy with life, looking out for their own good, and life has become more materialistic compared to the old days.

During the holy month of Ramadan, we used to visit our Muslim friends and break the fast with them. Elias told me to go before him to their houses to help them [with things]

Hekmat's church and a mosque, side by side in Al Zaitoon.

like tasting the food because they couldn't do this during
the fast. So I used to taste the food, telling them that this
needs salt, this is not cooked yet, this needs something else.
Then Elias came and we ate with them and spent a nice
time together. The day after, they would send for me again
to taste the food and then genuinely insist that I stay and
eat, but I refused because I couldn't eat their food every day.
But before they broke their fast, just at the time the sun was
setting, they sent a child from their family with a dish of the
food they cooked.

Sumaqiya is a typical Gazan dish and was sent by our
Muslim neighbours. I always kept their dishes until I made
something and then sent them back, or I kept the dishes
until the feast, when I made *borbara*, and sent it to them.
My husband used to tell me how many dishes of *borbara*

he needed for his friends, so when I cooked it I knew how much to make. Before our feast they used to remind me not to forget my *borbara* dish, and sometimes when I sent it to the neighbours they used to complain that it was not as good as what I had made the year before. Once a lady asked me how to make this dish. I said it was very tiring and I would make her two very big pots, but she said that even if I gave her all I could cook it would not be enough because she had a big family, and even a big pot would only be enough for a spoonful each to taste. So I gave her the recipe and while she cooked it she sent her son every five minutes with some of the wheat berries to see if it was ready. Finally I went there until it was cooked.

We cook it by putting the wheat berries in water on the stove and stirring without stopping until the wheat is almost cooked. It takes a long time. And then you add sugar and keep stirring until it becomes thick, and then add raisins and keep stirring, and then pour it into dishes. And then I add cinnamon and divide it into sections. To every square, I add different types of nuts: peanuts, coconut, and pistachios. Some people mix them in when they are still cooking it at the last stage. Then I give some to everyone.

4 / Business and Life Before and After the 1948 *Nakba*

ELIAS WORKED IN TRADE—exporting and importing—
and he had a shop with flour, rice, sugar, and all the
necessary things. But before he had his own shop he worked
in other people's shops, and when he made good money he
opened a shop and got a licence from the British Mandate
administration to work in import and export. He also rented
big warehouses where he stored large quantities of sacks,
which he distributed to merchants and shopkeepers. There
was always work, even during the wars, because people
don't stop eating; on the contrary, they want more during
emergency times, more than they need. They used to come
and sometimes fight and shout, asking for more and more,
fearing the shortage of food during the strikes or the curfews
and my husband calmed them and told them they would all
get what they wanted if they were quiet. Since I opened my
eyes in this life, Gaza has always suffered from problems,
attacks, and wars; whenever one finished and we had a
break, then another one began: another government, another
administration, another occupation, more problems, more
tragedies and fears, and people always stored food. They
were always afraid about what would happen to them and

their families in the future because a war could start in a minute, and if they didn't die from the war they would die from starvation. People were not only worried about their own families but also extended families near and far living all over Palestine. Elias worked in trade under three governments: the British, the Egyptian, and the Israeli.

My father-in-law married twice. His two sons, Hanna and Saleem, and three daughters from his first wife lived in Jaffa, and after she died, he remarried in Gaza. Elias was their first son, and later Jeryis and Subhi and another three daughters. All the children were very close, and Elias had very good relationships with his brothers and sisters in Jaffa. Because of his business, he used to visit there quite often and stay at their homes. Hanna was a big merchant in Jaffa. My husband used to buy from merchants in Jaffa, Tel Aviv, and Jerusalem, and I always went with him. We also visited Jerusalem during the feasts and to pray there. I know Jaffa and Tel Aviv street by street, like Gaza, because Hanna's brothers in Jaffa knew the good shops and their owners and took me there.[1] Elias also knew the shops in Tel Aviv, and I went with him many times before the 1948 *Nakba* to sell and buy goods. There was good business between us and the Palestinian Jews before 1948 and if there was business and money there were no problems. The people in Tel Aviv knew me and sometimes I would hear someone crying, "Hekmat, Hekmat!" when I was walking in the street, and wonder who was calling me, and they would say they were so-and-so from the warehouse. So I would ask them if they had something new and they would tell me to come the next week when there would be a new collection. I used to buy not only for myself but for friends and neighbours in Gaza because they didn't go there like me. I knew their sizes, so I wrote lists

and tried on dresses and shoes for them. I bought scarves, shoes, dresses, skirts—a big bag for relatives, neighbours, and friends. This is why they were so friendly in Jaffa, because they remembered me and used to wait for me. When I bought for my friends, I insisted on receipts. We trusted each other, but in things like this it was better to show the price so there were no misunderstandings.

We went to Egypt by train and Jaffa by taxi and Elias went to his business and I went to my brother-in-law's house and went shopping or walking around enjoying myself. I liked shopping and Elias liked to see me in modern clothes and I was famous for new styles of fashion in Gaza. Before the feasts women came to me to cut their hair or style it a different way. I told them to come three or four days before the feast and I cut their hair or curled it or made it straight because there were very few beauty salons in Gaza then, and I learned these things because when I went to Jaffa and Jerusalem I saw how women had their hair, and bought curlers and hairspray, and told them what the current style was.

Elias had a friend who was in charge of the police station in Haifa. Once we went to Haifa for fertility tests and booked into a hotel and phoned him. In fact, it was his idea; he told Elias there were good doctors in Haifa who might help us. He was very angry that we were in a hotel when he had a big house, and joked and said that he would order a police car to bring us to his home and if we refused he would put us in jail. So we went to his home and spent a very good night with his family.

Seven years after I was married, I learned to sew professionally. I had learned to sew earlier at a private school in Al Zaitoon and graduated with a certificate at the end of the course. At first I didn't like it because I didn't want to

be a dressmaker, but after I was married and wondered what to do with my spare time, my husband's family asked me to help sew things for them. I had forgotten what I had learned so I decided to do another course to brush up on the skills that I hadn't practised. So I took classes a second time because I wanted to learn this time, and received a second certificate. After I graduated the second time, I started to sew and became a professional. I used to sew for my husband's relatives and family and other people, and charged one pound for a dress. People said I was an expensive dressmaker but after they saw the result they said it was worth the money. I had magazines from which women chose the design they liked, and I advised them about which design suited them and which ones didn't: "This suits you, this doesn't; you are a bit fat, this will not suit you; you are short, you should not wear this," and so on. And they listened to me and trusted my advice.

I made clothes at home and became a skillful dressmaker, and I was very clever in sewing wedding dresses. I made many different dresses for brides, and I still remember a beautiful red dress I made for a bride, and after the ceremony when she changed into it and appeared in front of people, they all stood up and clapped in admiration of my work. She was very beautiful in that dress, and before I made it, I told her that I wanted to make her a dress of my own design, and to trust me to do it. So I made it without sleeves, narrow from the chest to the waist, and with a big skirt and many decorations. I also made a small jacket in case she wanted to wear it in front of conservative people when they came to visit her. Sadly, she later died of a disease that doctors had no cure for. Her family was devastated. The mother kept the red dress, and when she wanted to

remember her daughter, she went to the cupboard and took it out and often cried. I always keep them in my prayers.

Electricity came to Gaza during the British time, and it was installed by a Palestinian Jewish engineer who was born in Gaza. There used to be a very small neighbourhood where Palestinian Jews lived, beside Hammam Al Samra and close to Shuja'yya, and this Jewish family lived there.[2] When my mother was small, she used to play with him and his older sisters, who were the children of the Jewish neighbour. She also went there on Shabbat to help them cook because they weren't allowed to light fires or do any activity. A few times, she took the dishes to wash after they had finished eating because she didn't want them to be left for the next day, but when she realized it would happen every Saturday, she stopped and told them to clean the dishes on Sunday. (Water was expensive at that time and was sold by a man on a donkey.) Then the family left Gaza and moved to the north of Palestine where this man [the engineer] studied and then worked for the British. So when they sent him to check the electricity lines, he decided to pay a visit to my family.

At the time, my family had sent for me because my father was very sick, and we felt that he was close to death, so I spent three nights there. On the last night, the doctor came to see him and I followed him outside to ask about my father. He said that if he made it through the night he would recover, but if not it was *Allah*'s will, and he left. While I accompanied the doctor outside to ask about my father, I saw this man outside in the street staring at me. His eyes were fixated at me as if he were frozen. When I had finished with the doctor, he asked me if this was the Al-Taweel house, and I said yes. He told me he was the one who helped install the electricity in Gaza and that he knew my family, who

were his friends, and asked me why I did not age and looked so very young. All his sisters of my age had become old, and he asked me to tell him what I used so he could tell his sisters. I didn't understand what he was talking about, but I liked what I heard. Then he told me his name and asked if he could see my father. He had a strange name, and I told him my father was sick and asked him to wait and told my father that a man wanted to see him and told him his name. He said this was our old Jewish neighbour, and to let him in. He was still staring at me in a weird way as I took him inside, and then he kissed and hugged my father, and my father asked about his sisters and family. The man looked at me and called me my mother's name and asked why I was still so young, but my father said, "She is not Fayqa. She died a long time ago and this is her eldest daughter, Hekmat." My father burst out crying, as did I, and so did the guest, who started crying in loud voice. He was very shocked and couldn't believe it. He said he had come on business to check the electricity and at the same time to see if we lived in the same house, because he and his sisters were planning to visit. His sisters would also be very shocked to hear the news as they had prepared many things that my mother liked to bring with them. He was talking and crying and said that he would tell his sisters that he didn't find our address. Early next morning, my father died.

On his next visit to Gaza, the Jewish engineer came and asked our neighbour about my father, and when he knew that my father had died he was so sad. He didn't visit us after that. My father died in the forties, I think 1945 or 1946. He died when he was sixty-two years old, a few years after I was married, but my sister Maroom wasn't married during his lifetime. She later married a cousin of my mother and had

two daughters. One died two years ago and the second is still alive and had two sons; sadly, she miscarried one and the other died at birth.

5 / The Palestinian Resistance Against the British Mandate

THE ENGLISH FOLLOWED THE ACTIVISTS and the *Fedayeen* and it was forbidden to carry any kind of weapon of our own. Anyone caught with any sort of weapon was arrested and jailed for a long time. Once they caught my husband's cousin in a house in the field on the road to Khan Younis and brought him to Gaza. He knew they wanted to arrest him because they had come to his house the week before when he wasn't there. So he started sleeping at his friends' houses, and one day they went to search in one of the house and found him, and he was arrested. He was disguised and holding a *fanoos* [decorative lamp], pretending that he was helping the soldiers search the place, and nobody recognized him except Mr. Redding's son who was an officer, because he knew him and was a friend. When he arrested him he said, "I must arrest you because business is business, my friend."

During the English raids in our area looking for *Fedayeen*, my husband's cousin used to quickly escape from the top floor of our house and go over the wall to the Baptist Hospital, and from there he jumped to the nearby cemetery and disappeared. Once he brought a weapon, a rifle, and told me to

The cemetery connected to the CMS Hospital in Gaza City.

hide it in my room at home, and if the English came to search, to throw it out the window. There was a small wall separating us from the hospital, so he told me to throw it into the hospital grounds and not to tell anyone in the house because he trusted me and knew I wouldn't say anything. But the English didn't come to my house, and I kept the rifle until he came one day and took it.

When he was caught, he was almost killed but was lucky because he understood English, and he knew from what the soldiers said that they were going to kill him. One of them said to the other, "Let's tell him to run and when he runs we will shoot and kill him and say he was trying to escape." It was in their interest to get rid of him because he was one of the *Fedayeen* and jailing him wouldn't solve the problem,

when upon his release he would continue his struggle against them. This happened to many *Fedayeen* at the time of the British Mandate. This was also the case with many other young men who joined the *Fedayeen* movement during the late sixties and early seventies when Israel occupied the Gaza Strip. The Israeli soldiers used to shoot and kill them and then ask the family to come get the body of their son, saying that he attempted to escape. So when my husband's cousin heard this, he immediately started to shout, calling for the officer in charge, and when he came, he told him what the soldiers had said, and they were astonished that he understood English. Luckily, the officer was good, and he shouted at them and replaced them with another group of soldiers. There were also Palestinian civil police at the time, working under the British Mandate authorities, but they were to only solve small, local or family problems like when people fought with each other or when there was a family dispute, so they weren't involved in this kind of work.

As they were taking him to prison, they stopped in front of our home, maybe for a rest, and when Elias looked out the door, he saw his cousin surrounded by soldiers. He wondered how to speak to him, so he asked me to quickly make tea, which he took on a tray to the soldiers. While they thanked him and were drinking the tea, he asked his cousin how they had caught him, if they found anything with him, if he had told them anything, if he had money—these sorts of questions. He spoke very softly while he waited for the soldiers to finish their tea, and told him to be strong and not be afraid, and not to open his mouth, and that he would notify his family. Then the soldiers left with him, and my husband phoned his family and told them. He was a strong man and did not confess of anything. He was only given six months in

prison, and he was lucky he wasn't given a longer sentence like many other activists at that time. They asked him many questions, and they tortured him during the interrogation period, but he didn't say anything. When we found out that he had been given a six-month prison sentence, we and his family were relieved, and we were allowed to visit him later on.

On certain days, the English hung lists of prisoners' names and their dates of release on the entrance of the prison, so when people visited their sons they saw these lists. If they found a name they knew, they went by donkey to give the family the good news, because there were no telephones then. When telephones were installed, we were among the first people to have them in our house and people came a lot to use the phone. Sometimes I became fed up with all the people coming daily to make or receive calls, but Elias used to say that it was necessary, so to let them come. When I say many, I am talking about sometimes ten people a day who came to use the phone, mostly for urgent matters such as passing on news about a deceased or seriously ill person or an upcoming wedding. Sometimes it was just a normal call for someone they loved and missed, but this was rare as the telephone calls were expensive.

Once the English ordered all the men aged sixteen to sixty-five to leave their houses and gather at a certain place in Gaza. I was on my way to visit my aunt's place, and when I arrived I saw one of her sons, who was about sixteen years old but looked older than his age, at home, and wondered why he was still there. My aunt said he had refused to leave as he was scared, and that she was trying to convince him to go. So I told him that he should go because if he didn't he would be arrested or even killed, like the sons of one family

who didn't obey the British orders to leave. Yes, that time, according to what I heard from many people, the English ordered every man over the age of sixteen to go out and warned that whoever didn't would be killed. And in the case of that one family, the English killed their two sons. But my aunt's son didn't respond. My aunt was so worried and started to cry. I did not know what to do or how to help, so I decided to return home. Just a few metres after leaving the house, I saw two of our neighbours on their way out. So I rushed over and asked them to wait, and quickly returned to my aunt's house and told the boy to go with the neighbours, and the boy went with them. Then the English searched the houses that day, and his mother later told me that I had saved her son by convincing him to go. If I hadn't done so and he had remained and hid at home, he might have been killed like those other boys. When the English conducted house searches looking for a wanted person or just to terrorize the people, they would close the area and place a guard every few houses, and then they would order all men to line up against the wall of the Baptist Hospital and check them. Then other groups of soldiers entered the homes and searched every corner.

Towards the end of the English era, maybe in 1944 or 1945, the Women's Union [the General Union of Palestinian Women] and other women's organizations were starting to be established, though secretly, and they organized demonstrations to protest the unfair English policies and their oppression of the people. All the groups demonstrated together.[1] A midwife worked at the Baptist Hospital and she was very good at giving speeches. She was short so we put a chair on top of another chair so she could be seen and heard by the people. She stood on the chairs and asked me to hold

them for her while she was speaking. Every two minutes she stopped speaking to ask me in her loud voice, "Hekmat, are you holding the chair?" I would tell her not to worry and to go ahead with her speech because I was holding it very well, so she would say another five sentences and become excited, and then she would ask again, "Hekmat, are you sure you are holding the chair. I am afraid of falling." So I would reassure her again and tell her to continue her speech. I laugh a lot when I remember her in those situations but she was a very nice person and an excellent speaker as well.

When the 1948 war started, Hanna, Saleem, and their families in Jaffa were forced to escape. Jews lived in Tel Aviv, it was their centre, and as you know it's not far from Jaffa, less than 3 kilometres. Jaffa was often attacked by the Zionist Jewish militias coming from Tel Aviv. The beautiful bride of the Mediterranean, as we used to call it, suddenly become a very dangerous city. The city started to be regularly attacked by the Zionists as early as late 1947, as I remember that Elias cancelled two trips that we planned just a week before Christmas. Bombs were thrown at Palestinian homes, and at their cafés and businesses. Many innocent people were killed, and Elias became so concerned about his brothers and their families, and he used to call them every week to see how they were doing. The news about these attacks was spreading across Gaza and everyone was worried, especially when thousands of people, the inhabitants of nearby villages, started to take refuge in Gaza. Suddenly, everything became expensive and the demand on things, especially food and other necessities, became so high. There were shortages of many basic things. People were forced to flee, leaving their homes because of Zionist attacks, and whoever had a relative here in Gaza joined them, but the majority didn't have any.

So those unlucky ones found refuge anywhere they could—
on the beach, under the trees, and in the mosques and the
churches. Thousands of people came everyday, especially
from nearby villages, and almost every family in Gaza had
relatives who had escaped the war and ended up in Gaza.
Many people came to Al Zaitoon including my husband's
brothers who came to our home and stayed for a short time.
Hanna didn't want to stay and chose to go to Lebanon. When
they arrived in Lebanon, they phoned us because we were
so worried about them. Many people were killed on the way
while looking for temporary safe places and we didn't know
where they were or if they were still alive or had died. When
they phoned, they told us news of other people who had
fled from Jaffa and had families in Gaza, so we passed the
news to their extended families. During the 1982 invasion
of Lebanon, my husband's nephew, Hanna's son, had just
graduated as a doctor, and there was a big meal to welcome
him home. The Israelis shelled the area during the meal and
a bomb fell on him and split his head open while he was
sitting in the garden beside the wall, at the exact moment
his father was bringing him something to drink. We were
devasted when we heard the news. He was so young and so
smart and had a full future ahead. His dreams and his fami-
ly's dream were cut in an instant. May his soul rest in peace.
I always think of him and the other young people who were
killed in the wars, especially when I watch the news and see
the atrocities on TV these days. Sometimes I wonder how
Palestinian women and mothers can bear to live with all this
pain. There is wisdom in *Allah*'s will that I don't have chil-
dren of my own. Hanna used to visit us, leaving his children
in Lebanon, but after his son died, he never visited Gaza.
Even now they call me, but less often since Elias died. When

he [Hanna] calls, I feel the loss and the sadness in his voice. I wish he would visit us so we can comfort him. It is difficult to comfort someone in a short, long-distance call. Saleem, Hanna's other brother, came to Gaza and lived with us until he died, and all his sons are now outside Palestine.

Those people who didn't have relatives in Gaza suffered a lot and were given tents because there was no room for the tens of thousands of refugees arriving in Gaza at that time. International organizations estimated that about two hundred thousand people sought shelter in Gaza in 1948 but I think there was far more people than this. You know, I remember seeing streams of people, a continuous flow that you could see the beginning of but not the end. Women, children, men; people of all ages and from different places in Palestine who didn't know where to go or where to head. They were shattered. Many of them had never been to Gaza before and they did not know where to go. They were so tired, so they slept in the streets when the night came and continued their journey the next day. Many of them used their blankets or any cloth they had and put up some sort of tent. Gaza at that time was full of tents, all sorts and shapes of tents. It was so sad and heartbreaking to see these dignified villagers, many of them women and their children, with their beautiful embroidered traditional *towb* [gowns] and the city middle-class dwellers with their beautiful city dresses living in tents with nothing, literally nothing. Some people were even looking in the garbage and at nearby fields to find sticks, some wood, or anything to make fire and make bread and feed their families. The situation slightly improved when the UNRWA started work in 1950.[2] And before the UNRWA some other international organizations tried to help, but they couldn't cope because of the large

number of refugees. It was a stressful time for everyone, including the local people of Gaza. Many of them panicked because they watched these tens of thousands of nearby villagers becoming refugees living in tents with nothing. So the demand on flour and food increased, as did the prices of everything else. It was a time of great uncertainty. Local Gazans wanted to store as much as they could so that their families wouldn't end up hungry. So they showed up knocking on our door and shouting because of the fear of war and its consequences, one of which is food shortage. So they wanted to get as much as they could, especially flour. Driven by this fear, I also panicked and used to tell Elias to bring a sack of flour home in case it ran out, and he would always tell me not to be worried or afraid and to be sure I would not go hungry because we had enough, more than enough. I used to tell him, "You give to everyone, so consider me as one of those people and give me a sack of flour for the future." And he would just reply, "Trust me Hekmat. You won't go hungry as long as I am alive."

There were always poor and needy people, and no matter how much was distributed, there were always more people, beyond the capacity of the place and the local and international organizations. I remember organizations like the Quakers and the Red Crescent Society in 1948 and 1949, then the UNRWA in 1950, and others whose names I don't remember, but I recall their roles in helping those who became overnight refugees. At that time, the word *muhajreen*, which in English would translate to "immigrants" but in our case meant "refugees," became well known in Gaza; it was the new name given to the people who sought shelter in Gaza thinking they would stay for a short time then return. Dr. Haidar Abd Al Shafi, a native Gazan and a well-known

doctor in Gaza City, started the Palestine Red Crescent Society and during the fifties and sixties I worked with them.[3] Elias never objected to my work or activism with local organizations after the *Nakba*; on the contrary, he encouraged me to join. I had the freedom to go wherever I wanted, to join organizations and attend meetings all over. Many couples wanted to be like us because of our understanding and strong relationship despite not having children, which in our society is considered a big problem. Elias always encouraged me to study, read, and participate in activities, which later led me to take part in and become a member of the Women's Union, the Red Crescent Society, and the Women's Empowerment Society. If I didn't know about some activities or events, my friends would tell me about them and Elias would encourage me to participate, especially if it was voluntary work that benefited our community and people.

I worked as a volunteer with the Red Crescent Society. We would sew uniforms for the members: a dark blue dress with an armband of the logo on the sleeve. We would go to needy families to assess their situation, kind of like the work that a social worker would do, and give them assistance. The people would then give us names of other needy families whom we would also visit to offer help in the form of food—flour, rice, sugar, oil, and other things—and second-hand clothes, under the supervision of Dr. Haidar Abd Al Shafi. I also did the same with the Women's Empowerment Society, where we got help for these dignified families who lost everything in 1948 and became refugees, and there were many of them. We went to Gazan people's homes to collect money for our charitable work. We had a small box in our bags and if people wanted to give money, we presented the box and turned our backs while they gave as much as they wanted so that they

wouldn't be embarrassed. We also collected donations for the
Red Crescent. People sometimes stopped me in the market
or street and told me, "Hey Hekmat, we prepared some bags
of gently used clothes and other things, so come to collect
them." People helped as much as they could. I was amazed
by the generosity of our people and proud to be part of this
work, but at the same time sad to see such dire living condi-
tions and the situation of the people.

We took the donations, and the clothes or anything
people wanted to give that could be used, and would return
to the [Women's Empowerment] Society where we added
the money we had collected to the main collection box and
wrote the amount in a book. Some people who knew about
our work came themselves to give donations directly or
things they didn't want, or they called us, and we collected
them. We sorted the clothes into different piles and then
put a selection of clothes and food in boxes to distribute.
We were careful to choose what pieces of clothes we would
distribute, taking into consideration what would be appro-
priate for the specific families, so we knew they would be
worn. We also had to check with the families before we gave
assistance because there were some instances where a family
would refuse to accept the assistance because they felt it
was against their dignity. We put these boxes in a big car and
drove to the addresses and checked to see if they were needy
and then brought the box in for them. We never told people
that we prepared the box, but [said] that it had come from
outside and we didn't know what was inside, so it wouldn't
embarrass them. I did similar work in many other voluntary
organizations.

Usually I knocked on the door and when they answered,
I told them I was from this Society to give help, and because

I was married and the two girls who would do the rounds with me were not, I was the one who spoke to the men. We had to be careful in our work and to respect the customs and traditions of our society to succeed and continue to help and reach a large number of people. You know, at that time, young, single girls were rarely allowed to speak to strange men. When we were young and used to walk to and from school, if a strange man came to speak to a girl in my group, my friends would tell me to "tell him this" and "and tell him that" because they were shy or maybe afraid that someone would see this interaction and would tell their families that they were speaking to men. At that time, this was considered inappropriate behaviour. But I would usually speak, because I think there was slightly more freedom for girls in Christian families compared to girls in the Muslim ones. It was also the nature of my father's work as a merchant, and of course later my husband, that made it possible for me to talk to men. So if a man came to visit my father or uncle I was allowed to open the door, let him in, and greet him normally before calling my father. But in general, it was rare for girls, Muslims or Christians in Gaza, to speak freely with or have a conversation with any man alone.

6 / The Egyptian Administration and the Israeli Occupation

AFTER THE BRITISH came the Egyptians. They oversaw everything, and there were few problems during that era, which lasted between 1948 and 1967. In general, the Egyptians were good, helpful, and sympathized with the Palestinians and their cause, plus they are Arab like us and we understood their language. They are also similar to us in many ways; we share the same features, culture, customs and traditions. Sometimes, if the Egyptian soldiers or employees needed something, they knocked at our doors, so we helped them. They are different from the Israelis, who are strangers to us and came to steal our land. The Egyptians came to support us in our struggle to liberate our land. Their administration of Gaza aimed to help us organize our lives after the loss of Palestine. True, there were some problems during the fifties when the Egyptian government initially considered accepting the Johnson proposal to settle the refugees in the Sinai desert, but for the most part, they supported us. At that time, many people went into the streets and organized huge demonstrations against the Johnson proposal which ultimately made the Egyptians consider their decision. Many Gazan civil society leaders such as Mu'in Bseiso, Haidar Abd

Al Shafi, and my friend Yusra Al-Barbari, all based in Gaza, led these protests. In some situations, clashes took place between the demonstrators and the Egyptians police. Some people were arrested. Shops and businesses were closed for a while. Students stopped going to school. Gaza was on fire. I also joined these protests and prepared banners that read "Down, down Johnson proposal" and "Right of return is sacred." It was only when the Egyptian administration withdrew its support for that proposal that peace and order returned to Gaza's streets. Apart from that difficult time, the Egyptians did many good things, such as making university education free for Palestinians in Egypt. Many of my relatives and my husband's relatives studied in Egypt and received their degrees in professions such as pharmacy, medicine, and engineering. They also established People's Universities to help people who couldn't travel to Egypt to pursue their education in Gaza, and I studied in one of those.

During the Egyptians' administration of Gaza I desperately wanted to find a job, but my seventh-grade education wasn't enough, so I studied at the English department of the Egyptian People's University, which taught French, Spanish, German, and English. This university, which was operated by the Egyptians, was only for languages, and the teachers were local. I wanted to learn English because I had started learning it at school and I liked it very much. Many of my school friends attended other language classes, and I wished we could have been in the same class, but they said they had already learned English and wanted to learn French. But I thought it was better to be strong in one foreign language than to be weak in two. My friends who studied French left after a while and didn't continue because it was difficult and they could not practice or use it in their life or even

find easy books in the French language to improve their language skills, but I continued with English classes and was happy I chose it. I studied English there for a year and a half, submitted all my exams, and graduated with a diploma. This improved my language and refreshed the knowledge that I had been accumulating.

This might have been in the end of the fifties or early sixties, and the university was in Al Daraj. It was located in a small, rented house with many classrooms, and was open for anyone who wanted to study, young or old, married or single. Many married women came to study. You know, one student who came to study English in my class had a university degree but she wanted to improve her English. I registered late, three months after they had started, and I was very worried that I wouldn't be able to catch up or understand what the teacher was saying. So I went to Yusra Al-Barbari, who was in charge of that university, and told her about my concerns and worries. I was worried as it had been a long time, maybe twenty years, since I was in school, so I was afraid that I had forgotten what I had learned and would not be able to follow what the teachers were saying. Knowing me well, Yusra told me not to worry because the level of the other students was probably the same as mine, and joked that her main worry was that I would become first in the class, not that I would fail it. When I attended the classes, I quickly caught up and the worry left, and at the end of the course I was second in that graduating group, and the one with a university degree came first. But thank *Allah* I studied and graduated, even though I was three months late, and achieved second place in the department. I felt proud. I think encouragement is so important for both adults and children. Without the support of Yusra I might not have

attended university. She was a wonderful, humble, and stubborn woman with a big heart and an even bigger mind. For me, she reflects Gaza's spirit in many ways.

When we did the exam, my friends sought my help to answer some difficult questions, so they wrote them using pencils on a ruler and passed it to me. Then I wrote the answer on the ruler and gave it back. When the teacher saw the ruler moving around the room she became suspicious and asked why. I said, "Because they don't have rulers and need to use mine, so what can I do?"

The teacher said that starting tomorrow she would bring rulers for everyone, and this was the last time she would allow them to use mine. So we laughed to ourselves because she didn't understand, and they got the help they needed. I know it is no right to cheat but it was just one difficult question. The next day the kind teacher brought everyone rulers. I laugh when I remember those days. It was such an enjoyable learning atmosphere and we did many childish things even though we were adults.

Yusra was very active. She was the head of the Women's Union, the supervisor of our university, and also the social studies inspector in Gaza schools. She had a university degree from Egypt. We were good friends. When I studied at the People's University we went on trips to the park or to the beach, and she used to ask my advice about organizing these activities, such as when to go and where to go, so we would set up the schedules together. There was a mixture of participants: single and married, old and young, refugees and local Gazans, Muslims and Christians. We would divide into small groups to keep order.

When Elias's business in Jaffa and northern Palestine ended, he got a licence from the Egyptians and imported

flour, rice, oil, and other foodstuffs from Egypt to sell to people. I used to go with him when he had business there, and in the afternoons we went together to the coffee shops in Cairo, especially those on the Nile. We also went to the cinema and theatres and enjoyed casual strolls in the streets as we shopped around. I used to buy things for my neighbours, especially shoes and bags because they were of good quality, and were very good and strong, lasting a long time. Once I bought shoes for a girl from our neighbourhood and they didn't fit because they were a bit small, so she returned them to me and didn't want to take them. So I jokingly said, "Did I get them from my father's factory? I bought them like you asked, the same colour and size, so it's not my problem if they don't fit you." The girl's mother cried from laughing and took the shoes back and left while still laughing. It is good to have a sense of humour and I always tried to resort to jokes to make my point. We are all the same after all, human beings, but different in our views and ways of looking at things. Plus, I have learned through life that dealing with people requires patience and some wisdom.

We visited Jordan and Egypt five or six times after 1948 and stayed in hotels and visited friends there. Usually Elias went with his friends for business and the wives went shopping. When I was a volunteer in the women's organization we went for a trip to Alexandria, and Elias also took me to Alexandria later on one of his business trips to Egypt. It is a very beautiful city with magnificent, wide beaches and clean sand. We enjoyed the place and had lots of fun and good memories. Elias and I liked travelling very much. Even in Gaza we visited relatives and friends in Deir Al Balah and Khan Younis and went to the beach to breathe the fresh air, and to a restaurant called Abu Huwaidi that I liked a lot. The

food was delicious and the waiters were very friendly. People said we liked going out a lot, but why not? Why not going out and enjoy our time? We didn't have children to look after and keep us at home. So we enjoyed our life. We participated in all sorts of social events like weddings and engagement parties, church activities, and festivals and trips. We were happy together. There was love and understanding between us. I miss my husband a lot.

Things completely changed after the Israeli military occupied the Gaza Strip in 1967. Raids on our streets and homes and night searches for the activists and the *Fedayeen* were conducted almost every day. They shot and arrested many of them. It was a very difficult period. In many instances, I opened the door and saw the Israeli soldiers either coming or leaving our streets, or sometimes standing in front of our door. Once the Israeli soldiers came to search our house in Al Zaitoon. They opened my wardrobe and searched it and when they saw my hats and high-heeled shoes, dresses and short skirts, they asked where I got them and I said they were from Tel Aviv and Jaffa. When the officer heard this, he looked at me and told the soldiers to leave, saying, "Since they buy from Tel Aviv they don't cause problems."

When Israel first occupied Gaza, we would hear the sound of many planes in the sky followed by bombs that were being dropped on the houses. We saw and heard the Egyptian soldiers and *Fedayeen* running in the streets, and lots of shooting, but we stayed in our homes, terrified, and rarely went out. Some of those soldiers knocked on our door seeking water or men's clothes to change their uniform, after hearing the news that Egypt had been defeated and that their lives were now at risk. We helped them. When the war ended and we were allowed to get out of our houses, the

people found many bloated dead bodies, Egyptian soldiers and Palestinians, as it was so hot then. Then people buried them. *Haram.* I don't like to remember those days as it makes me cry. It was a very frightening and upsetting time.

During the war we hid in the church beside our home because it was a very large, strong building and we thought it would be safer than our homes. Most of the people had no place to hide so tens of thousands of them headed to the nearby fields or hid under the big trees that were near the beach. They were scared that the Israeli soldiers would search the homes and drag the men out and kill them as had happened in 1956 during the tripartite attack on Egypt by France, Britain, and Israel. In that war, Israel temporarily occupied Gaza and carried out a massacre. Over a thousand men had been slaughtered in Khan Younis and Rafah alone.[1] Everyone in Gaza was expecting another massacre, so many people left their homes. We, too, were scared to death. I still remember the faces of my relatives and other neighbours sitting in the church next to their sons and husbands and sobbing. Having no children of my own or brothers, my eyes were always fixated on Elias, thinking, "What would I do if I lost him? How can I protect my husband?" While in the church, Elias and the other men were making sure that every family had a blanket and those with food and water shared with those who didn't. When the situation was quiet, the people who lived near the church went first and then came back to tell the others whether it was safe or not. After the occupation of Gaza many curfews were imposed at night for many years. The first few years after the 1967 occupation were very difficult with lots of raids and arrests. Many of our neighbours got killed and many others got imprisoned. Almost every man who was over the age of sixteen was

stopped and integrated. Once I was in Gaza's Old City facing the Baptist Hospital on my way home when I saw Israeli soldiers lining up young men with raised hands against the hospital walls. While I was passing beside them, a soldier hit a teenager so hard in the face that he fell against my chest, crying in fear, "My mother, my mother."

I replied spontaneously, "Oh, my dear!" and the soldier asked if he was my son. I shouted, "Yes! Why are you beating him? What did he do to you?" The soldiers told me to take him and go home quickly so I grabbed him and quickly walked away until they couldn't see us. Then I asked him where he lived, and whether he wanted me go with him to his home. He thanked me and refused to take my offer, and continued alone so I left him beside the old mosque and returned home.

During curfews we often asked my husband's relative, whose home was close to the street, to buy things like cigarettes and dates for us. So this relative bought things and threw them over the wall to us. Sometimes curfews were imposed in Al Zaitoon but not in Al Daraj, so venders came to sell, even though it was dangerous, but people had to survive. Sometimes they were beaten if they were caught and put in jail, sometimes the soldiers pretended not to see them. When they came to the hospital to sell, we put a basket over the wall and bought vegetables from them. I remember when someone cooked meat or nice meals we could smell, we said they were lucky because they had meat for their meal, so later we raised chickens and pigeons in our home to eat, and to have eggs during the curfews. I always raised pigeons in my husband's house and took them with me when we left to rent another house in Al Zaitoon. Now whenever I pass by Al Zaitoon, I see my pigeons; I am sure they are from my

pigeons because I was the only one who raised this type. They used to fly from my house and make other nests, so I am pretty sure these are from my pigeons.

Elias and his brothers and sisters in Jaffa owned big pieces of land, three of four hundred *dunum*, in Al Sawafir village to the north of Gaza City. As you know, he had four brothers and six sisters, and he used to go to Al Sawafir and lived there during the harvest, wore the traditional village clothes, and supervised the work. After the harvest, he divided it into equal shares for his brothers and sisters and then called them to collect their share or sell it or do whatever they wanted, and he brought ours home. He was known in Al Sawafir for being honest, and all his brothers and sisters trusted him. He always brought coffee from Al Sawafir whenever he visited, and I always asked him why because we had a lot in our kitchen, but he said that he liked the added cardamom and the way they crushed it with a big mortar and pestle in front of him.

Once I went with Elias to Jaffa after 1967 when the Israelis allowed Palestinians to enter Israel to work or to visit. On our way back he wanted to show me our land in Al Sawafir. He showed me where the land was situated, where it started and ended; indeed, it was a very big piece of land. He showed me what was planted: sesame here, wheat there, barley here, and corn over there. While he was showing me, an Israeli settler came running, asking what we were doing here, and my husband said, "Nothing. This land belongs to us and I came to show my wife in case I die, so she will know it."

"It's not your land, it's my land that I bought."

Elias was very angry to hear that and shouted at him, "That is a lie, this is theft, and *haram*. This is my land. Just

go and search the English land registers and you will see who the rightful owner is."

The settler said, "If I had known this before, I would not have bought it." He is a big liar. Everyone knows that Palestine is an Arab land and that its inhabitants were forcibly kicked out of their houses. These houses are Palestinian houses, they were built by Palestinians, the furniture is made by or bought by Palestinians, the clothes hanging in the closet and the embroidered dresses in wardrobes belong to Palestinians and the kitchen stuff and spices are Palestinian. How come he said he didn't know? This was a robbery in broad daylight with the complicity and the full support of the British who betrayed us. How dare he say that he did not know. He is a liar.

A few years ago I went to buy some vegetables at Al Zaitoon, and as I was chatting to the vendor, another man selling vegetables beside him interrupted and said, "Excuse me, did you say you were from the Al Sayigh family?"

I said, "Yes, I am. My husband's family is Al Sayigh," and asked where he was from.

He said, "From Al Sawafir," and asked if I knew Elias Al Sayigh.

When I told him that he was my husband, he said he was a great man and asked how he was now. I told him he had passed away and the man was shocked to know and looked at the ground for a minute trying to hide his tears. He was so sad to hear this. I felt a wave of emotion come over me from this man's reaction. The shopkeeper noticed and brought me a chair to sit on and a glass of water. I chatted with the man for a bit and then got my shopping basket and went home. I did not cook that day. I was depressed and lost my appetite.

My two brothers-in-law lived in Jaffa and they were well known there, and before 1948 when Elias went there for his business we stayed at their houses. After the 1967 war, when we were permitted to visit there again, we felt it was different because Israel had changed everything. It was still the same place we once used to know, but things were completely different. Once we visited the homes of my brothers-in-law in the suburb of Al 'Ajami and found that the Israelis had made one of them into a kindergarten. The Israeli woman in charge wouldn't let us in, and astonishingly Elias told her, "My brother's house has become a kindergarten? This was our home and we came to see it. Why won't you let us in?"

The woman said, "What are you saying? How can this kindergarten belong to your brother? It belongs to the State of Israel."

Elias said, "This is the house of my brother Hanna Al Sayigh. I don't want anything from the house; I only want to see it."

So the woman let us in and we found infant babies sleeping in the beds. We went to the kitchen, which was now an office, and my husband said to me, "Look Hekmat, this is the water well. Hanna's family used to get water from it when there was a shortage."

When the woman heard this, she said, "What are you saying?" So he showed her the well and she said that this was the first time she had heard about it and said that she always wondered what this place was.

Then he took me outside the house and we headed towards the smaller wooden building that encompassed a wooden room that had wooden benches which had been used for hot baths, almost like a sauna. There was a bathroom

inside the house, but this place was outside for leisure and relaxing. The woman said, "Now I understand what this place was used for."

My husband's niece was a very good artist and she had painted a very big picture, the size of a sofa, of a villager carrying a jar on her head and her children by her side, and it hung on the wall. It was still hanging on the wall of Hanna's house and Elias said, "This is the work of my niece, and here is her name and her signature."

The woman was surprised and said, "We didn't know these things."

My husband was very sad and had been trying to prevent himself from crying in front of the woman, but when we left he burst into tears and said, "Look Hekmat, my brother's home which he built from his blood has become a kindergarten. I can't imagine that these strangers who have no right to be here are living in my brother's home, and preventing us from visiting it. If Hanna saw this, I am sure he would not be able to withstand this theft. He might even die."

He was very heartbroken at the sad reality of becoming a stranger in his own home. Yes, it was his brother's home, but he considered it his own home. We lived there when we used to visit Jaffa, sometimes on a weekly basis, and we had very beautiful memories there. Elias left heartbroken and remained very sad for quite a while after we returned to Gaza.

We also visited the house that belonged to Elias's brother Saleem, and again the Israeli occupant, a Jewish woman, wouldn't let us in and closed the door. But we didn't accept this, so we rang the bell again and attempted to speak to them, but they just didn't want to listen. I entered the house while my husband argued with the woman. This was the only way to see the house. When I entered and saw another

picture painted by my husband's same niece, I said, "This is Emma's picture," because her signature was underneath.

The woman stopped arguing with my husband and asked, "Who's this Emma? Everyone visiting the house asks what Emma means."

I said, "This is the name of the girl whose uncle used to live here. She liked painting very much and this is her picture. She's also my husband's niece."

"Ah, yes now I understand."

Then I explained the other pictures in the house, which were paintings of family members, and the woman asked, "These are pictures of the family?"

I said, "Yes, she was very good at painting."

So we ended up entering the house by such means, but there was no other way to get in. I was highly moved and influenced by my husband's tears and wanted to help him get in to see his brother's home at any cost. The woman kept saying, "No, no, no, you cannot enter my house," as I unapologetically walked into the house with my husband following, while still arguing with the woman, and when we stopped at the picture, she also stopped and became interested in what we were saying. My husband's niece was very good at drawing and painting and was the first [in her class] in Palestine. Her pictures and drawings were always hung at art exhibitions in Jaffa and other cities. Always. Now Saleem's family lives in Lebanon, and after we visited the house we phoned them and told them about the visit. Saleem was very upset to hear the story. These visits were about thirty years ago, before my husband died. Maybe those pictures are still hanging on those walls. Who knows?

Elias and I lived together for a long time in the family home. One brother built his own home and another brother

moved as well, and then we also left and rented a beautiful house in the same area. We moved from that rented house to another one, and then another one, and years later I had lived in five different houses altogether. We had also lived for a little while in my sister Maroom's house when she was in Kuwait with her husband. They rented their house to a man and when the lease ended and he left, we stayed there for about a month until we found someone else to rent it. Maroom lived most of her life in Kuwait after she was married because her husband had work there. Then she returned to Gaza, and a few years later, in 2000, she died. May she rest in peace.

7 / Yusuf, the United States, and Palestine

WHEN WE RENTED THAT BEAUTIFUL HOUSE, Elias's nephews always came to visit. We loved them and they loved us very much. Elias and I also liked the neighbour's children a lot, and we treated them as if they were our own; we loved children very much, and this is why we raised our neighbour's child. My husband used to visit them and liked Yusuf because he looked like one of his nephews who now lives in America. Yusuf's family would always tell us, "Take him as your son and let him call you mother and father."

But I said, "No, *haram*, while you are still alive. It's easier for him to call us grandmother and grandfather, and you his parents."

Yusuf started sleeping at our home when he was two months old. His mother would bring him in the morning after she fed and changed him, give me his bottle, and then go to do her work. In time we got so used to each other that when his mother took him to sleep at home he cried a lot and she couldn't get him to sleep, but whenever I took him he stopped crying and slept.

Eventually he came more and more to our home, and my husband used to take him to his shop for a while, and

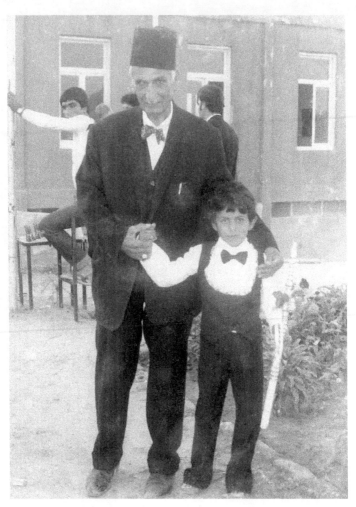

Elias and Yusuf.

when Yusuf became bored, he sent him back home with the neighbour's son. A very close and good friend of my husband used to cry when he saw Elias holding Yusuf in his arms or carrying him on his shoulders, walking in the street or buying him candies or kissing him. He used to say, "I can't hold my tears when I see you holding him."

When Yusuf started school, he used to come to my home to see what I had cooked and then saw what his mother had cooked, and chose between what he felt like eating that day. He knew his family and played with his brothers and sisters, but he was settled in our home and ran between both. Before the school year started, my father used to buy exercise books, pencils, pens, erasers, and things for school in bulk, so I did the same with Yusuf.

Elias understood English and Hebrew. He and his cousin learned Hebrew after 1967 when they conducted business with the Israelis and needed to communicate. A teacher used to come to our house to teach them Hebrew, and he learned quickly because it is very similar to Arabic. He often translated the news or television programs for me. Once he went to meet some Israeli merchants he used to buy from and he told them that he wanted to stop working and finish doing business with them because he had become an old man. The merchants didn't like to hear this and said, "You shouldn't leave your business. Give it to a son because it makes a lot of money, and you are a very good and smart man, and we want to continue working with your children." But Elias told them that he didn't have children and couldn't continue. I was with him at that moment, and I felt very sad because it was a sensitive subject that we had tried to forget. Then the Israeli merchant said, "I'm sorry madam; I didn't mean to offend you. I am like you, I don't have children either." Then he told my husband, "You know, you are an exceptional person. We learned from our government that you are an honest and good man, working for your people and their benefit. The Egyptians wrote the same report in their files during their time, and the British during their time. It was an honour to work with you." Elias stopped working at end of the 1970s.

One of Hekmat's sewing students receiving her graduation certificate.

I worked for ten years as a sewing teacher at the Council of Churches, from 1985 to 1995. I had a lot of spare time and wanted to do something, so I applied and was accepted because of my good reputation and skills, and later I became a supervisor for the sewing section. When there was funding, the Council of Churches gave the women and girls material to practice, but towards the end of my work, there wasn't enough [financial] assistance. So I told my neighbours and friends, if they wanted a dress or jacket, to give me the material and we would do it, which would benefit them as well as the girls who needed the training. So they gave me the material and their measurements, and then the students did the same thing with their neighbours.

They were astonished at the Council of Churches that, at my age, I knew good English, so whenever a foreign group visited, I escorted them and explained our work. As soon as the man in charge of the Council introduced us, he went and sat on his chair, and I took over. I liked this job very much because I enjoy socializing and talking with foreigners and people of different cultures: getting to speak to them, finding out about their culture, and also getting to practice my English. I also felt they were very happy with me because we could understand each other. We laughed and made jokes; it was a really happy time that I enjoyed a lot.

During the first *Intifada*, the uprising that erupted at the end of 1987, the Israeli soldiers came at night knocking at doors and searching for men, checking identity cards, and arresting people, very similar to what the British used to do. When they came to search my home, I used to tell them to come in, and I opened cupboards. I wanted to show them I was not afraid and was confident that I wasn't hiding anything in my home. Sometimes this worked; I would hear them say, "She doesn't have anything. If she did, she wouldn't be doing this." Once when they knocked at my door, they had asked our neighbour who lived here. He told them that the house belonged to an old Palestinian Christian lady. The officer said, "Do you think that because they are Christian they don't do anything? Christians are worse than Muslims." Many Muslims had Christian friends whom they trusted and to whom they told their secrets. And many Christians had Muslim friends whom they trusted and to whom they told their secrets. We worked together to protest and defy the British policies. We did the same when Israel occupied Palestine. This is why the Israeli officer said that Christians were worse than Muslims, because there are no

differences between Palestinian Christians and Palestinian Muslims. We lived together in peace and harmony and with no problems, because in the end we are all Palestinians.

During the *Intifada* there were many demonstrations and the Israelis always threw tear gas and shot rubber and live bullets at demonstrators, but thank *Allah* Yusuf was never arrested. Once the Israeli soldiers asked all the men over sixteen to leave their houses and go beside the Baptist Hospital wall close to our home. My husband went and I told Yusuf to go but he refused. I sent a small boy with a bottle of water for my husband because it was very hot as they were sitting under the sun for long periods of time. I sent bottle after bottle. I was afraid, and very worried that they would search the houses and find Yusuf and take him. The soldiers came to my house to search and Yusuf hid underneath our bed, and to this day I don't know how they didn't find him. I was terrified during the search, panicked at the idea of them capturing him and killing him. I remembered my neighbour's son who was the same age as Yusuf, and the conversation I had with his mother after he refused to go out when the British ordered every man over the age of sixteen to get out before searching homes. I would say that this moment was one of the most frightening of my life.

We saw many difficult days in our lives, especially after the Israeli occupation in 1967. If I were to talk to you from now until 2050, I wouldn't be able to finish all the stories.

My husband became very sick late in his life. Once I returned home late and explained that the road to our house was closed because an old mosque was being restored so I had to take a detour. He said, "Are they restoring it? I would very much like to see it. How are they doing it?"

I said I was sure it was going to be very beautiful when it was finished because I saw the new windows and dome. He felt as happy about the mosque being restored as he would have been if a church was being restored because he liked places of worship. When he died and we opened his briefcase, we found many receipts of donations he made to mosques and to people in Gaza, some I knew and some I didn't, and he never told me. He had written all the details and I was surprised at how much he had given. May his soul rest in peace.

The last eight months of his life he couldn't walk and laid in bed all the time. We used to support him under his shoulders to help him walk, and during this time the doctors came and went all the time, but he was old. And once, when he felt that he was very sick, he called me and told me he might die. He spoke about Yusuf and said, "Hekmat, if you want to keep the boy do so, but if you don't, let his family know. It is your choice." I told him no, I wanted Yusuf to stay with me, and he was relieved to hear that and said it was the answer he wished to hear before leaving me. Yes, I raised him like my own and he still lives with me. He is now more than my son.

Now, when my husband died, some of our families stayed for a few days during the mourning period, and when they left, Yusuf went to his home and collected his clothes from his family's house where he had stayed during this time. His mother asked what he was doing, and he said, "You told me the people visiting my grandmother have left. Now she is alone so I should go and be with her." I was crying when he came, and he told me that he would never leave me alone and would be with me forever. So after my husband died, Yusuf settled in my home, eating with me and sleeping under

Hekmat and Yusuf.

my roof. Elias died when he was about eighty-five years
old, and I was devastated. When he died and we took his
body to the church to pray for him, Yusuf stood beside him
crying, holding and kissing his hands and face. He sprinkled
a bottle of perfume over him until it was finished, and I was
so worried because he was so young and so affected by the
death that I asked a man to take him outside for a while.

When someone died, we prayed in the church and distrib-
uted dates and black coffee, and then buried them. After
the first forty days, then at six months, and at one year, we
prayed again in the church, asking for forgiveness for the
deceased. We also placed announcements, with the time and
date of the memorial services, in the newspapers.

Yusuf finished *tawjihi* [high school] and then studied computer science at the science and technology college in Khan Younis. After college he attended the Al Quds Open University, which had recently opened in Gaza, where students can work at their own pace, and he has not finished yet.

He worked for a long time at a photography shop. The daughter of the shop owner liked looking at photos and would gaze at the photos in the shop windows as she passed by with her friends on their way home from school. Yusuf noticed the girl and was smitten with her. He started to talk to her when she brought her father lunch during the school's summer break. Then one evening he told me that he loved a girl, and he wished to marry her. I told him, "What are you waiting for?" So, we went to her family and asked for her hand in marriage. The family agreed and Yusuf was so happy. They were engaged for a few months and then we started planning their wedding. Yusuf is now thirty-two years old and he is married to the girl he loves. We live together. Yesterday, they had their first baby, a girl. They named her Haya. The baby and her mother are both healthy and well. Now when my husband's relatives call from America, they ask about Yusuf and his wife, and yesterday they phoned and congratulated us about the birth of their daughter.

| Once when I went to America, I told my relatives I wanted to pray at the Baptist church, and they wondered why because I am Orthodox. But I wanted to see whether they were similar to what they were like in Gaza. I was very surprised because I met the wife of a minister who had lived in Gaza. She was very strict. She used to tell the girls in Gaza that wearing gold or low-cut dresses or short skirts was bad, and always made them feel as if they had committed a sin. I saw her there,

Hekmat with Yusuf's new baby and two friends.

Hekmat with baby Haya.

wearing makeup and gold and a very low-cut dress, the complete opposite of what she used to say. I deliberately stared at her, and kept staring because I wanted her to know she was a hypocrite and only working for money.

I want to tell you a funny story. Once I visited America to see my husband's nephews and their families. I returned with Air France, so we had a stopover in France before changing planes to go to Tel Aviv. A man beside me was an American, and he might have been a businessman because he opened his laptop and started to work. We were all in our seats before we left, and a hostess came to check our tickets. She asked me where I was from and I said, "Gaza."

She said, "Impossible! Impossible! Are you sure that you are from Gaza and not a visitor to Gaza?"

I said, "Yes. I am Palestinian from Gaza. Why are you saying this?"

"Because people from Gaza have rings in their noses."

I said, "Those are not the people of Gaza. Maybe you're talking about some Bedouin's wives, but most people in Gaza are like me—not only like me, but look and dress better than me."

She said, "Impossible!" and then left, and the man beside me closed his laptop, got up, and left the plane. And suddenly all the other passengers also started to leave, and I wondered where they were going. I looked around me and there were no other passengers apart from another woman and a small child, so I left my seat and went to speak to her, and she told me she was from a village in Bethlehem and the small child was her son. I asked her why she thought the people had left the plane, and she said she didn't know. Then I got bored so I moved from seat to seat, looking through the window and changing my seat several times. Only the hostess, the

pilots, the lady, and her son and I flew to Tel Aviv, and I still wonder where the other passengers went. Maybe because I said I was from Gaza and they thought I might have been carrying a bomb or a gun or was a terrorist, as they portray us in the American films that these people watch! Even in the airport people tried to avoid talking to me when they heard I was from Gaza. This was in the mid-nineties. Now when I remember this I laugh a lot, because if they were afraid of an old woman thinking I am a threat to them, why didn't they search me? But they had searched me before I got onto the plane, and checked my visa several time—and I am an old Palestinian woman, not a man. What would the situation have been like if I were a young man? If they were scared, they could have asked to search me again so they wouldn't miss their flight and probably lose their money.

What I want to say is that ordinary people in the West are good, but many are ignorant and misinformed about what is happening in our part of the world. The main problem is the governments that side with Israel, and also the media that is spreading lies about us and making us seem like something so different and dangerous. How would the hostess come up with the idea that Palestinians in Gaza have rings in their noses? And even if this was the case, what is the problem? And how come people get scared of an old woman like me and consider her a threat to their lives because she is a Palestinian? I told the man with the laptop who was beside me on the plane, before he left, "We like Americans but not the government of America."

He asked why and I said, "Because you are always with the Israelis who steal our land and kick us out of our homes. You support them whether they are right or wrong."

But he said, "Who told you this? We support the Arabs too."

I said, "No, *you* maybe like or support Arabs, but not your government. If they support us as you say, then how come they agreed to allow Israel to occupy our land and make our people refugees?" And he replied with silence. I wanted to continue the conversation, but the hostess showed up and ended it with her silly question.

My husband's three nephews live in America and they were the ones I went to visit. Two are engineers and one is the director of an accounting firm. The three of them live far from each other. I stayed there twenty-two days, spending a week at a time with each one of them. And also saw their sisters, two of whom have married Americans, and the other has married her relative. All live and work there now. When I visited them, they asked me if I had seen anything strange in America. I said, "Nothing is strange or surprising for me because there is no difference for someone who moved and travelled a lot across Palestine, who also went to restaurants, cafés, cinemas, and trips in all parts of Palestine, buying and selling and living life; it's no different than there."

When I visited America, I went to Boston first. Then to Seattle, and this is where the nephew who regularly calls me, especially if there is big news in Gaza, lives. He told me, "You know, whenever I hear the name 'Gaza' in the news I just sit and open my eyes and ears, waiting for the coverage, and I feel my heart thumping because I am afraid that something bad has happened to you and the people of Gaza."

He keeps urging me to come to America and live with them. "Who do you have in Gaza? It is safer here. I'll send you the money for the ticket, so come, please. We are your sons and we live here so why do you stay alone in Gaza? You can be with us. You can even bring Yusuf and his family. Think about it."

And I always say, "I can't leave Gaza. I want to stay in my city and my homeland with my people and die and get buried here."

Last week he called and said he might come next month when the situation becomes a little calmer, and he will take me back with him.

| When my husband became very old, I urged him to move from Al Zaitoon and rent or buy another place, but he told me he would stay there until he died, and that after he died, I would be free to move wherever I wanted. So after he died I wanted to stop renting, and five or six years ago I left Al Zaitoon and came here to Rimal and bought this apartment in this tower. I liked the place when they were building it, but now I don't know whether it was a wise decision or not because I am lonely and bored all the time from being in this closed apartment, and sometimes I wish I hadn't bought here. If I had stayed in Al Zaitoon, I would be beside my neighbours and friends and we would see each other, and if I didn't leave my house there, they would at least come to find out why. You know, there I felt the love and strong relations between people: love, solidarity, cooperation, and care for others. On their way to the market they would pass by and ask if I wanted anything, and I did the same, although they did this more because they had children to help carry the things. So I would tell them to buy things for me. Community relations between people there is very strong and there is no difference between Christians and Muslims. It is a very beautiful and healthy environment, which I miss here in the city as everyone is busy with their own lives and work. Here people only visit on special occasions or if they need something from me.

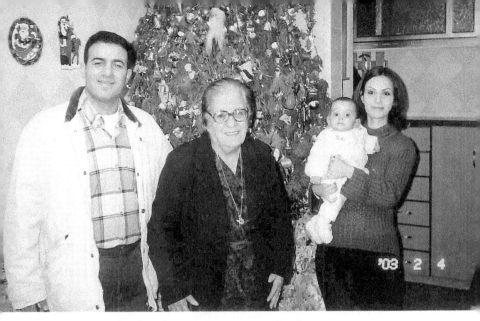

Yusuf and his family under a Christmas tree in their home in Rimal, Gaza.

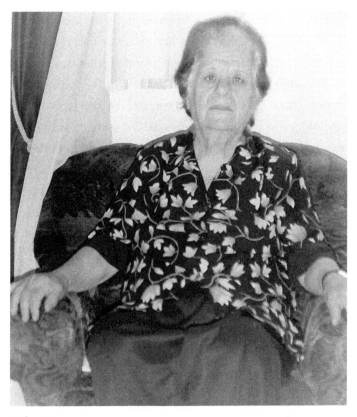

Hekmat.

Now I go and visit my neighbours and friends in Al Zaitoon every Friday, the Muslim weekend, and if I don't, they phone and ask why I didn't come. I tell them to visit me, but they say my home is far and when I come I can see all of them. So the next Friday I go there, and as soon as I leave the taxi and walk into the street, everyone calls me. Children usually wait for me to give them chocolates and sweets, and if I don't have any, I give them money to buy some and they share with each other. I like children very much and I believe that whoever does good deeds will receive good things from *Allah*. They try to take me to their homes so I usually sit in a certain home and everyone comes to see me. I have a friend there who is very old, over ninety years, and refuses to walk, so when I go there I tell her she should walk, and with another person we take her for a small stroll around the house. She gets so happy when she sees me. Me, too. I become happy to see her and to see everyone.

Many people in Gaza know me because I am social person who loves talking to people. I also mixed with a lot with people all over Gaza while I worked and volunteered with the societies I mentioned before, and my husband had many relatives and friends who knew me, so whenever I go out now people stop and ask me how I am. When I ask who they are, they say they are the children of so-and-so. A short time ago I saw Yusra Al-Barbari by chance in the middle of the market, and she shouted my name and hugged me while jumping from happiness. I was embarrassed because many people stared at us, but she said, "It's our country and we were here before they were born. Let them say what they want."

| I didn't have a Palestinian passport before, when we used to travel, because we didn't need it. We had identity cards

that we were required to show to the British and then the Israelis when we travelled across Palestine. People used to use Palestinian passports during the British Mandate, but I never had one as I never travelled outside Palestine before 1948. After the 1948 *Nakba*, we obtained an Egyptian travel document and used it when we travelled. And then the Palestinian passports were issued again after 1994.[1] When I travelled to America, I had a Palestinian passport. I think this is one of the good outcomes of the Oslo agreement, as it allowed us to have our own passports. It has also allowed us to visit more countries. We thought the situation would be better after Oslo but in fact it is the opposite. The situation is going from bad to worse. Whenever we think that peace has come, that our problem is resolved, and that the time to rest and celebrate has finally arrived, another problem arises. We grow up with these never-ending problems, attacks, and wars. I wonder when we will be allowed to live in peace like everyone else in this world. We don't want wars. Now so many people have lost their homes in this *Intifada*, and every day the Israeli army demolishes more houses and assassinates people. I follow the news every day and when they shell Gaza City, especially at night, we feel it is so close, as the walls of our building shake. Usually the power goes out during these attacks and we don't know what they are targeting. During power outages we light candles to be able to see, and then next morning when the power comes back we hear from the news where they have hit and see the destruction. This *Intifada* is scarier than the first one especially as the Israeli military is now shelling Gaza with the Apache and the F16. Also, the fact that we have a baby now makes me terrified. This is *haram*. You know I was very worried throughout this past month, and I was counting the days

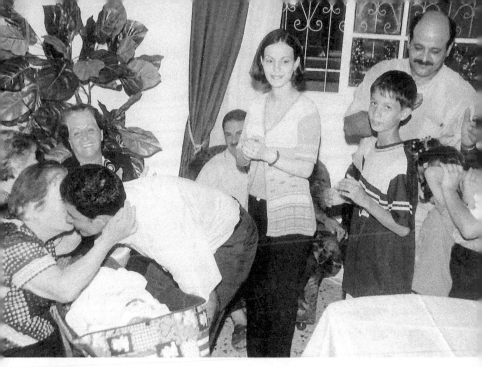

Hekmat with Yusuf, his family, and neighbours celebrating the arrival of baby Haya.

until Yusuf's wife delivered her baby. I was afraid that her water would break during the shelling or the power outage and that we wouldn't be able to take her to the hospital. I am relieved that she had her baby, and that we were able to get her to the hospital on time.

I will never trust any agreement or say peace is coming until I see it with my own eyes. Many peace agreements have been signed but the promised peace has not come. The agreements remained only on paper, like the countless UN resolutions on Palestine that sit on the shelf collecting dust. The only time I will believe there is peace is when I see calm, the end of occupation, and the return of the *muhajreen* to their homes. I will never believe the news about peace on the radio and television until we feel this peace in our lives,

peace that ensures and fulfills our rights and dignity and gives us an independent state.

From when I opened my eyes in this life to this moment, we have been living in wars and problems. First the oppression and the problems with the British, then the *Nakba* of 1948. After the *Nakba* we had the aggression of 1956, followed by the occupation of Gaza during the 1967 war. Then the first *Intifada* and now *Al Aqsa Intifada*. Whenever we have a small break, Israel initiates tension, and the conflict is ignited again, causing more tragedies, more widows, more martyrs, and more destruction to our communities. I believe that our problem is not as complicated as people may think. Also, people don't know much about Palestinians. They think we are terrorists and threats to them. Very few know the reality that we fight for our homeland that was destroyed and occupied in broad daylight. Very few know about our homes that were occupied by strangers while their owners were kicked out. The story of my brothers-in-law is one of tens of thousands of stories. How can the Israelis enjoy their lives when they are living on stolen land and in stolen homes? This is *haram*.

Now in this *Intifada*, the situation is very difficult, and we become like prisoners in our own country and sometime in our own homes. I always wonder why all these problems happened. The Jews used to live peacefully with us, and we bought from them and sold to them for many years, and everything was fine until Palestine was placed under the British Mandate. The English are the source of our problem. They destroyed Palestine first when they issued the Balfour Declaration,[2] then by their support to the Zionists that enabled them to take over our land.

Despite all of that, we have a strong faith, and we remain hopeful that a just peace will finally come. Certainly, we will not give up our land because it is our land, and it is our duty to defend it. How can we accept the occupation and the oppression? It is impossible. Have you ever heard of a people who has given their homeland to strangers or to foreigners, and accepted being occupied and jailed in their lands? Have you ever heard of that? Tell me.

The news speaks about a two-state solution, but they have their own state and we are denied having a state of our own. The news keeps talking about peace, but we don't have peace. What we want is not talks about peace but a real peace that secures our rights and dignity. What we hope for is not promises of a state but an actual state. We have been yearning to establish our independent free state for such a long time now, and I can tell you that every Palestinian here and outside is very upset by these broken promises. I can also tell you that despite the frustration I still believe that one day we will have peace in our land. I have no doubt about that. We are staying on this land and there is no way that we will disappear. I know that many Israelis wish we would vanish, but this will not happen.

We have everything required to establish an independent state: well-educated people, good leaders, and a young society. And we have deep roots in this land, we have an ancient history that goes back to the time before Jesus. But more than anything else, we have the right to this land, and a strong faith. With this faith, we will never give up our hope that one day Palestine will be free. It might not be in my lifetime, but it will eventually come. *Allah* is most generous and one day we will have peace.

This is the Holy Land where Jesus was born, and I pray and will continue to pray for peace and to protect our youth and to stop the killing and the assassinations, because we have seen enough and we deserve to live in peace. I will always pray to free our land, and free our Palestine.

Chronology of Events in Palestine

1516–1917

Palestine incorporated into the Ottoman Empire under Selim I on
August 24, 1516, with its capital in Istanbul.[1]

1897

AUGUST

First Zionist Congress convened in Switzerland from August 29
to 31. It issues the Basel Program calling for the establishment of
"a home for the Jewish people in Palestine." It also establishes the
World Zionist Organization to work to that end.

1914

JULY–AUGUST

Outbreak of World War I as Austria-Hungary declares war on Serbia
on July 28 and Germany declares war on Russia and France on
August 1 and 3, respectively.

OCTOBER–NOVEMBER

The Ottoman state enters the war on the side of Germany when it
begins a naval attack on the Russian Black Sea ports on October 29.
Russia declares war four days later.

1916

MAY

Sykes-Picot Agreement is secretly signed, dividing Arab provinces of the Ottoman Empire between Britain and France.

1917

NOVEMBER

British Foreign Secretary Arthur James Balfour sends letter (Balfour Declaration) to Baron de Rothschild on November 2, pledging British support for the establishment of a Jewish national home in Palestine.

1918

SEPTEMBER

Palestine is occupied by Allied forces under British General Allenby.

OCTOBER

End of World War I on November 11, with the signing of the Treaty of Versailles.

1920

JULY

British civilian administration is inaugurated on July 1. Sir Herbert Samuel is appointed first High Commissioner.

1921

MARCH

Founding of *Haganah* (defence), the Zionists' illegal underground military organization.

1922

JULY

On July 24, the League of Nations Council approves Mandate for Palestine without consent of Palestinians.

1923

British Mandate for Palestine comes officially into force on
September 28.

1929

AUGUST

Serious unrest occurs centring on al-Buraq Wall, also known as
the Wailing Wall, a site that holds significance for both Jews and
Muslims in the heart of old Jerusalem. In June 1930, the League of
Nations sends a fact-finding committee to investigate the reasons
behind the uprising. After five months of investigations, the
committee concludes that the area around the wall is an Islamic
endowment, but that the Jews can continue their prayers at the
wall with certain restrictions.

1935

OCTOBER

Irgun Zvai Leumi (National Military Organization), *Irgun* or IZL for
short, founded by Revisionist groups and dissidents from Haganah,
advocates a more militant policy against Palestinians.

1936

MAY

Great Palestinian Rebellion begins in April with the killing of two
Jewish people and a general strike.

AUGUST

On August 25, Lebanese guerrilla leader Fawzi Al Qawuqji enters
Palestine, leading 150 volunteers from Arab countries to help fight
the British.

1939

OCTOBER

The Stern Gang, or *Lochemay Herut Yisra'el* (LEHI; Fighters for the Freedom of Israel), is formed by dissident IZL members led by Avraham Stern.

1942

Formation of the Free Officers by Abd Al Nasser and others. This occurred in steps.

1944

JANUARY

Stern Gang assassinates Lord Moyne, British Minister of State, in Cairo.

1947

MAY

Appointment of eleven-member Special Committee on Palestine (UNSCOP) on May 15, with its first meeting on May 26.

SEPTEMBER

Arab League denounces UNSCOP partition recommendation on September 16.

Arab Higher Committee rejects partition on September 30.

OCTOBER

Jewish Agency accepts partition on October 4.

NOVEMBER

Partition Plan passed by UN Resolution 181 on November 29.

On November 30, Haganah calls up Jews in Palestine aged seventeen to twenty-five to register for military service.

Arab League organizes Arab Liberation Army (ALA), a voluntary force of Arab irregulars under guerrilla leader Fawzi Al Qawuqji, to help Palestinians resist partition, at a meeting on December 8.

1948

APRIL

IZL and Stern Gang, led by Menachem Begin and Yitzhaq Shamir, massacre 245-250 inhabitants of Deir Yassin village near Jerusalem on April 9.

MAY

British Mandate ends on May 15. Declaration of State of Israel comes into effect on May 14.

The US and USSR recognize the State of Israel on May 15 and 17, respectively.

UN Security Council appoints Count Folke Bernadotte as its mediator in Palestine on May 20.

Al Nakba begins on May 15.

JUNE-JULY

First truce in the Arab-Israeli War lasts from June 11 to July 8.

JULY-OCTOBER

Second truce is ordered by the UN Security Council on July 18 and lasts until October 15.

SEPTEMBER

UN mediator Count Bernadotte is assassinated in Jerusalem by Stern Gang on September 17.

DECEMBER

Israel Defence Forces (IDF) brigade attack on isolated Egyptian forces in Faluja pocket is repulsed.

UN General Assembly passes Resolution 194 (III) on December 11, declaring the right of Palestinian refugees to return.

1949

FEBRUARY

Israeli-Egyptian Armistice is signed on February 24: Egypt keeps coastal strip from Gaza to Rafah and evacuates Faluja pocket.

1950

APRIL

On April 24, 1950, the Jordanian parliament officially declares the Unification of the West Bank and the Kingdom of Jordan. The territory now officially known as the Gaza Strip remains under Egyptian military and administrative rule. While preventing political expression and organization, Egyptian policy preserves the Strip's Palestinian identity, keeping it separate from Egypt as a "Palestinian entity" pending implementation of the relevant UN resolution.

MAY

UN General Assembly establishes the UNRWA (UN Relief and Works Agency) based on Resolution 302 of December 8, 1949.

1951

SEPTEMBER

Yasser Arafat reorganizes the Palestinian Students' Union in Cairo.

1952

JANUARY

British along the Canal Zone attack an Egyptian police post in the city of Ismailia on January 25 and kill fifty Egyptians.

On January 26, more than 750 business establishments burn in Cairo, with thirty people killed and about a thousand injured.

JULY

Egyptian Revolution by the Free Officers, which overthrows the
monarchy on July 23.

1953

AUGUST

Sharon, the Israeli commander of Unit 101, attacks Al Bureij camp
in eastern Gaza and kills approximately forty Palestinians.

1954

JULY

British sign a treaty to evacuate their forces from Egypt.

1956

JULY

President Nasser nationalizes the Suez Canal on July 26.

OCTOBER

On October 29, 1956, the tripartite (Britain, France, Israel) invasion
of Egypt—the Suez War—is launched. Israel occupies the Gaza
Strip (declaring it to be an "integral part of the historical Jewish
past") until March 7, 1957, when it is forced to withdraw by the
United States and (to a lesser extent) the USSR. The four-month
occupation was marked by clashes with the local population and
is best remembered by Gazans for IDF "screening operations" in
search of men involved with the *Fedayeen*; close to five hundred
Palestinian civilians were killed in these operations, and scores
of Palestinian fighters were summarily executed. In all, the IDF is
estimated to have killed between 930 and 1,200 Palestinians before
withdrawing from the Strip.

NOVEMBER

Israel occupies Gaza and most of Sinai by November 2.

Israel commits a massacre in Khan Younis on November 3.

1957

MARCH

Israel withdraws from Sinai and Gaza by March 6-7. UN Emergency Force moves in simultaneously.

1959

JANUARY

Fatah is established by Yasser Arafat and associates.

JUNE

UN Secretary General (Hammarskjold) puts forth proposal A/4121 for the absorption of Palestinian refugees by the Middle Eastern states on June 15.

1962

OCTOBER

Johnson Plan for Palestinian refugee problem is proposed.

1963

JANUARY

First office is opened by Fatah in Algeria, headed by Khalil Al Wazir (Abu Jihad).

1964

JUNE

Palestine Liberation Organization (PLO) is founded on June 1, with Ahmad Shuqeri as its first chairman.

1967

JUNE

Six-Day War lasts from June 5 to 10. Israel begins military occupation of the West Bank and Gaza Strip of Palestine, as well as Sinai of Egypt and Golan Heights of Syria.

NOVEMBER

UN Security Council endorses Resolution 242 on November 22, calling on Israel to withdraw its army from the territories occupied in the 1967 war.

DECEMBER

Popular Front for the Liberation of Palestine (PFLP) is established, led by George Habash.

1970

SEPTEMBER

Military confrontation occurs between Jordanian army and Palestinian guerrillas ("Black September"), after Palestinian guerrillas hijack four planes on September 6 and 9. Two thousand Palestinians are killed and PLO leadership and troops are expelled from Jordan. PLO sets up new bases in Beirut.

Gamal Abd Al Nasser dies on September 29.

1971

DECEMBER

UN General Assembly Resolution 2787 recognizes the right of Palestinians to struggle for the recovery of their homeland on December 6.

1972

JULY

Ghassan Kanafani, a writer and a member of the Political Bureau of the PFLP, is killed when a bomb explodes in his car on July 8.

OCTOBER

PLO representative Wael Zwaiter is shot and killed in Rome on October 16.

1973

APRIL

Israeli raids in Beirut on April 10 result in the murder of three Palestinian resistance leaders: Kamel Nasser, Kamal Adwan, and Abu Yusuf Al Najjar.

OCTOBER

October or Yom Kippur War begins on October 6. Egypt and Syria fight to regain the Arab territories occupied by Israel in 1967.

UN Security Council Resolution 338 is adopted on October 22, and calls for an immediate ceasefire, the implementation of Security Council Resolution 242 (1967) in all its parts, and negotiations for peace in the Middle East.

1975

APRIL

The 1975-1976 civil war in Lebanon starts on April 13.

1978

MARCH

The Israeli army attacks southern Lebanon on March 14-15, throwing 25,000 troops into a full-scale invasion, leaving scores of Lebanese villages devastated and seven hundred Lebanese and Palestinians, mainly civilians, dead.

SEPTEMBER

On September 17, Carter, Begin, and Sadat sign the Camp David Accords, which propose a settlement of the Middle East conflict and a framework for the conclusion of an Egyptian-Israeli peace treaty.

1981

JULY

Israeli jets bomb PLO targets in Beirut on July 17, killing more than three hundred people.

1982

JUNE

On June 6, Israel invades Lebanon with an estimated 100,000 troops.

AUGUST

The evacuation of PLO troops from Lebanon begins on August 21, as about four hundred troops board a ship to Cyprus.

SEPTEMBER

President-elect Bashir Gemayel and forty followers are killed in Beirut on September 14, a few days before his inauguration.

Over two thousand Palestinian refugees are slaughtered in the Sabra and Shatila refugee camps in Beirut on September 16.

1984

JANUARY

On January 11, the World Zionist Organization executive body rejects the nomination of former Israeli Defence Minister Ariel Sharon as director of the Israeli immigration program, citing his role in the massacre of civilians at the Sabra and Shatila refugee camps.

1985

MAY

On May 20, in agreement with Palestinians, Israel exchanges 1,150 Palestinian prisoners for three Israeli soldiers captured during the invasion of Lebanon.

OCTOBER

Israel bombs the Tunisian headquarters of the PLO on October 2, killing more than sixty people, in retaliation for the September 26 killing of three Israelis in Cyprus.

1987

JULY

Israeli military authorities ban Palestinians from fishing in the Gaza Strip area for an indefinite period.

DECEMBER

The *Intifada* begins on December 9. In Gaza, four Palestinians are killed and at least seven are injured when an Israeli truck collides with two vans of Palestinian workers returning from work in the Jabalia district of Gaza.

1988

JANUARY

On January 19, Israeli Defence Minister Yitzhak Rabin announces a new policy for dealing with the *Intifada*: "Force, might, beatings."

APRIL

On April 12, Major General Ehud Barak, deputy Chief of Staff, states that 4,800 Palestinian activists are being held in Israeli prisons, including nine hundred in administrative detention.

Palestinian leader Abu Jihad (Khalil Al Wazir) is assassinated at his home in Tunis on April 16.

In a report on April 17, *The Washington Post* reports that the Israeli cabinet approved the assassination of Abu Jihad (Khalil Al Wazir), and that the operation was planned by the Mossad and Israel's army, navy, and air force.

DECEMBER

During the first year of the *Intifada*, 318 Palestinians are killed, 20,000 wounded, 15,000 arrested, 12,000 jailed, and 34 deported, and 140 houses are demolished. Eight Israelis—six civilians and two soldiers—are killed.

1989

JULY

On July 12, economic adviser to the Chief of General Staff and Director of the Defence Ministry's Budget Department estimates that the cost of fighting the Palestinian uprising is expected to reach approximately one billion New Israeli Shekel by the end of the current fiscal year, in March 1990.

1990

MAY

Israeli gunman massacres seven Palestinian workers and injures scores of others at Rishon Lezion near Tel Aviv on May 20.

AUGUST

Iraqi troops invade Kuwait on August 2.

SEPTEMBER

Israeli military authorities raze twenty-six shops and seven homes, and seal four buildings in the Bureij refugee camp in response to the killing of an Israeli soldier.

1991

JANUARY

On January 14, the PLO's second top-ranking official, Abu Iyad (Salah Khalaf), is assassinated in Tunis. Abu al-Hol (Hay Abu al-Hamid) and Abu Mohammed (Fakhri al-Umari) are also killed.

MARCH

On June 18, the Tel Aviv district court sentences Ami Popper, a cashiered soldier, to seven consecutive life sentences plus twenty years in prison for the shooting to death of seven Palestinians in Rishon Lezion in May 1990.

APRIL

Israel releases 240 Palestinian prisoners.

1992

DECEMBER

Israel deports 415 Palestinian activists to Lebanon.

1993

JANUARY

The first round of secret Palestinian-Israeli talks on a draft declaration of principles in Norway begins on January 22.

SEPTEMBER

Chairman Arafat and Prime Minister Rabin exchange letters of mutual recognition on September 9.

The Israeli-Palestinian declaration of principles, also referred to as Oslo, is officially signed at the White House by Peres and Mahmoud Abbas on September 13. The declaration provides for a five-year transitional period of limited Palestinian self-rule to begin in Gaza and Jericho, after which final status talks (Jerusalem, refugees, settlements, borders) for a permanent settlement are to be held. The agreement affirms that the West Bank and the Gaza Strip constitute a single territorial unit.

1994

MAY

The Gaza-Jericho Autonomy Agreement (Cairo Agreement) is signed on May 4, outlining the first stage of Palestinian autonomy— in Gaza and Jericho—including Israeli redeployment and the establishment of a Palestinian self-governing Authority. Israel remains in control of the settlements, military locations, and security matters. The stipulated interim period is to end on May 4, 1999.

The first Palestinian police forces arrive in self-rule areas on May 13.

JULY

Chairman Arafat returns to Gaza on July 1, accompanied by a limited number of Diaspora Palestinians, and swears in the first Palestinian Authority ministers on July 5 at Jericho.

1995

SEPTEMBER

The Interim Agreement on the West Bank and the Gaza Strip (Taba or Oslo II Agreement) is signed in Washington on September 28. It outlines the second stage of Palestinian autonomy, extending it to other parts of the West Bank, divided into Area A (full Palestinian civil jurisdiction and internal security), Area B (full Palestinian civil jurisdiction, joint Israeli-Palestinian internal security), and Area C (Israeli civil and overall security control). The election and powers of a Palestinian Legislative Council are determined. The target date for completion of further redeployment is October 1997, and the final status agreement date is October 1999.

NOVEMBER

Israeli Prime Minister Rabin is assassinated on November 4.

1996

JANUARY

The first Palestinian elections with an 88-member Palestinian Legislative Council are held on January 20, and Yasser Arafat is elected as the first president of Palestine.

1997

JANUARY

The Hebron Agreement (also known as the Hebron Protocol) is signed on January 17, in which Israel agrees to withdraw from 80 percent of the city, but will retain control over an enclave of 450 settlers and 35,000 Palestinians in the city centre.

1998

OCTOBER

The Wye River Memorandum, the agreement for the implementation of the Oslo II Agreement and resumption of final status talks, is signed on October 23. It divides the second redeployment provided by Oslo II into three phases, totalling 13 percent of the West Bank, and includes changes in the PLO Charter, the opening of the Gaza airport and safe passage, a reduction in the number of Palestinian police, and the release of Palestinian prisoners. Subsequently, Israel withdraws from 2 percent of the West Bank, near Jenin, the Gaza airport is opened, and some detainees, mostly criminals rather than political detainees, are released.

1999

SEPTEMBER

The Sharm el-Sheikh Agreement for the implementation of the Wye River Memorandum is signed on September 4. It stipulates Israeli withdrawal in three stages from another 11 percent of the West Bank, the release of 350 Palestinian political prisoners, the opening of safe passages, and the beginning of permanent status talks on September 13, 1999, to reach a framework for a settlement by February 2000 and a final peace agreement by September 2000.

2000

SEPTEMBER

Al Aqsa Intifada erupts on September 28 after Likud opposition leader Sharon makes a provocative visit to Al Aqsa Mosque with maximum security, and with thousands of forces deployed in and around the Old City of Jerusalem.

2001

JANUARY

From January 21 to 27 at the Taba Summit, peace talks between Israel and the Palestinian Authority aim to reach the "final

status" of negotiations. Ehud Barak temporarily withdraws from negotiations during the Israeli elections.

FEBRUARY

Ariel Sharon is elected as prime minister on February 6 and refuses to continue negotiations with Yasser Arafat at the Taba Summit.

AUGUST

Abu Ali Mustafa, the General Secretary of the PFLP, is assassinated on August 27 by an Israeli missile shot by an Apache helicopter through his office window in Ramallah.

2002

MARCH

The Beirut Summit, held over March 27 and 28, approves the Saudi peace proposal.

MARCH-MAY

On March 29, Israeli forces begin Operation "Defence Shield," Israel's largest military operation in the West Bank since the 1967 war.

2003

APRIL

The quartet of the United States, European Union, Russia, and the United Nations propose a road map to resolve the Israeli-Palestinian conflict, proposing an independent Palestinian state.

SEPTEMBER

Mahmoud Abbas resigns from the post of prime minister on September 6.

2004

JULY

On July 9, the International Court of Justice issues an advisory opinion that the West Bank barrier is illegal under international

law. The United Nations had also condemned the construction of the wall as "an unlawful act of annexation" on September 3, 2003.

NOVEMBER

Yasser Arafat dies at the age of seventy-five on November 11 in a hospital near Paris, after undergoing urgent medical treatment since October 29, 2004.

2005

JANUARY

On January 9, 2005, Abbas wins the Palestinian presidential elections by a wide margin.

AUGUST–SEPTEMBER

Israel disengages from Gaza and removes its settlements from the Gaza Strip, but retains effective control over air, sea, and land access to the Strip.

2006

JANUARY

Ariel Sharon is incapacitated by stroke on January 4. He dies on January 11, 2014, having never emerged from his coma.

On January 25, the Islamic resistance movement, Hamas, wins the Palestinian elections and beats Fatah, resulting in an international and Israeli boycott of the new Palestinian government and a blockade on the Gaza Strip.

2007

NOVEMBER

On November 27, the Annapolis Conference, for the first time, establishes a "two-state solution" as a basis for future talks between Israel and the Palestinian Authority.

2008/2009

Israel launches a twenty-three-day war on the Gaza Strip on December 27.

2012

NOVEMBER

Israel launches an eight-day offensive on the Gaza Strip on November 14.

On November 29, the UN General Assembly passes a resolution granting the state of Palestine non-member observer status, an upgrade that allows the Palestinians to join UN bodies, such as the International Criminal Court (ICC), to investigate war crimes in Gaza.

2014

On July 8, Israel launches a fifty-one-day offensive on Gaza.

2017

US president Donald Trump recognizes Jerusalem as the capital of Israel on December 6. The move is condemned by most of the world in a vote at the UN General Assembly on December 22.

2018

AUGUST

On August 29, the US State Department ends aid to the Palestinian refugee agency, UNRWA, reversing a policy of support by every US president since it was created about seventy-two years ago as a cornerstone of US support for stability in the Middle East.

MARCH

Mass protests start in the Gaza Strip on March 30 (better known as the Great March of Return), calling Israel to lift the eleven-year illegal blockade on Gaza and to allow Palestinian refugees to return

to their villages and towns from which they were expelled back in 1948.

MAY

The US moves its embassy to Jerusalem on May 14 and protests sweep the Gaza Strip met by violent repression from Israel, resulting in the deaths of at least 60 and the injury of 2,770 Palestinians in Gaza.

2019

MARCH

On March 25, US president Donald Trump recognizes the Syrian Golan Heights, occupied in 1967, as part of Israel.

NOVEMBER

On November 18, the US says it no longer considers Israeli settlements on the West Bank to be illegal.

2020

JANUARY

On January 28, the US administration reveals the "Deal of the Century," also called "Peace to Prosperity," a plan that jettisons the two-state solution—the international formula proposed to end the Arab-Israeli conflict. The plan, widely described as an attempt to get Palestinians to trade in their political demands for economic benefits, fails to acknowledge major political issues such as the occupation, the siege of Gaza, illegal settlements, and the refugees.

2021

MAY

On May 10, 2021, and after weeks of tension at Al Aqsa Mosque compound in Jerusalem, Israel launches another massive air attack on Gaza that lasts 11 days, leaving hundreds of Palestinians dead and wounded.

Notes

PREFACE

1. Rosemary Sayigh, *Voices: Palestinian Women Narrate Displacement* (Al Mashriq, 2005/2007), https://almashriq.hiof. no/palestine/300/301/voices/. Unfortunately, this important website is not currently active, though you can access parts of it through the Internet Archive.

2. Edward Said, *Covering Islam: How the Media and the Experts Determine How We See the Rest of the World* (New York: Pantheon Books, 1981), 154.

FOREWORD

1. Patrick Wolfe, "Settler Colonialism and the Elimination of the Native," *Journal of Genocide Research* 8, issue 4 (2006), accessed August 18, 2022, https://doi.org/10.1080/14623520601056240.

2. Ghada Ageel, "Once Upon A Land," in *Apartheid in Palestine*, ed. Ghada Ageel (Edmonton: University of Alberta Press, 2016): 3-19.

3. See, e.g., Madeeha Hafez Albatta, *A White Lie*, eds. Ghada Ageel and Barbara Bill (Edmonton: University of Alberta Press, 2020); Sahbaa Al-Barbari, *Light the Road of Freedom*, eds. Ghada Ageel and Barbara Bill (Edmonton: University of Alberta Press, 2021). See also forthcoming volumes in the Women's Voices from Gaza series (University of Alberta Press).

4. Darwish is often quoted as saying something along these lines in a speech to the International Parliament of Writers in Ramallah in 2002. These themes are also central to his epic poem *State of Siege*. See Bei Doa, "Midnight's Gate," *Positions: East Asia Cultures Critique* 13, no. 1 (2005): 55-74; Mahmoud Darwish, *State of Siege*, trans. Munir Akash and Daniel Abdel-Hayy (Syracuse: Syracuse University Press, 2015).

5. *Mashriq* is an Arab term that comes from the Arabic root -*sharq*, which has several meanings: "the east," "the sunrise," and "the Orient." Generally speaking, it refers to the eastern part of the Arab world—that is, the Levant countries (Palestine, Jordan, Lebanon, and Syria)—as well as Iraq, Kuwait, Egypt, and so on. The term also describes the part of the Arab world located in Western Asia and eastern North Africa.

6. John Collins, *Global Palestine* (London: Hurst, 2011), 2.

INTRODUCTION

1. "Where We Work, Gaza Strip," UNRWA, accessed February 11, 2021, https://www.unrwa.org/where-we-work/gaza-strip; BADIL, *Survey of Palestinian Refugees and Internally Displaced Persons 2016-2018*, Vol. IX (Bethlehem, Palestine: BADIL Resource Center for Palestinian Residency & Refugee Rights, 2019), https://www.badil.org/en/publication/press-releases/90-2019/5013-pr-en-231019-55.html.

2. Salman Abu Sitta, *Mapping My Return: A Palestinian Memoir* (Cairo: The American University in Cairo Press, 2016), ix.

3. Abu Sitta, *Mapping My Return*, ix.

4. Mahmoud Darwish, "Those Who Pass Between Fleeting Words," *Middle East Report* 154 (September/October 1988), https://merip.org/1988/09/those-who-pass-between-fleeting-words/.

5. Eóin Murray, "Under Siege," in *Defending Hope: Dispatches from the Front Lines in Palestine and Israel*, ed. Eóin Murray and James Mehigan (Dublin: Veritas Books, 2018), 30.

6. "The State of the World's Refugees 2006: Human Displacement in the New Millennium," UNHCR, April 20, 2006, https://www.unhcr.org/publications/sowr/4a4dc1a89/state-worlds-refugees-2006-human-displacement-new-millennium.html.

7. United Nations, *Gaza in 2020: A Liveable Place?* August 2012, https://www.unrwa.org/userfiles/file/publications/gaza/Gaza%20in%202020.pdf. See also Bel Trew, "The UN Said Gaza Would be Uninhabitable by 2020—In Truth, It Already Is," *Independent,* December 29, 2019, https://www.independent.co.uk/voices/israel-palestine-gaza-hamas-protests-hospitals-who-un-a9263406.html; Donald Macintyre, "By 2020, the UN Said Gaza Would be Unliveable. Did It Turn Out that Way?" *The Guardian*, December 28, 2019, https://www.theguardian.com/world/2019/dec/28/gaza-strip-202-unliveable-un-report-did-it-turn-out-that-way.

8. Yasmeen Abu Laban and Abigail Bakan, *Israel, Palestine and the Politics of Race* (London: I.B. Tauris, 2019), 29.

9. Mark LeVine, "Tracing Gaza's Chaos to 1948," *Al Jazeera*, July 13, 2009, https://www.aljazeera.com/news/2009/7/13/tracing-gazas-chaos-to-1948; Salman Abu Sitta, "Gaza Strip: The Lessons of History," *Palestine Land Society,* 2016, http://www.plands.org/en/articles-speeches/articles/2016/gaza-strip-the-lessons-of-history.

10. LeVine, "Tracing Gaza's Chaos to 1948."

11. Ilana Feldman, cited in Levine, "Tracing Gaza's Chaos to 1948."

12. Benny Morris, *Israel's Border Wars, 1949-1956* (Oxford: Clarendon Press, 1993), 416.

13. Ihsan Khalil Agha, *Khan Yunis wa shuhada'iha* [Khan Younis martyrs] (Cairo: Markaz Fajr Publishing, 1997).

14. Abu Sitta, "Gaza Strip."

15. The Johnson proposal was a joint UN and Egyptian government project that aimed to settle Gazan refugees in the northwest area of the Sinai Peninsula. Palestinians saw this as a plan to complete their ethnic cleansing and do away with their cause. The Refugees' Committee, together with active political groups and civil society leaders, led the protests against the proposal. Many Palestinians were arrested by the Egyptian police, including Gaza's grand poet and activist Mu'in Bseiso, who spent eight years in an Egyptian jail. For more details, see Abu Sitta, *Mapping My Return*; and Sahbaa Al-Barbari, *Light the Road of Freedom*, eds. Ghada Ageel and Barbara Bill (Edmonton: University of Alberta Press 2021).

16. Helena Cobban, "Roots of Resistance: The First Intifada in the Context of Palestinian History," *Mondoweiss*, December 17, 2012, https://mondoweiss.net/2012/12/roots-of-resistance-the-first-intifada-in-the-context-of-palestinian-history/.

17. "Israeli Colonies and Israeli Colonial Expansion," CJPME Factsheet Series No. 9, *Canadians for Justice and Peace in the Middle East,* 2005, https://www.cjpme.org/fs_009.

18. Zena Tahhan, "The *Naksa*: How Israel Occupied the Whole of Palestine in 1967," *Al Jazeera*, June 4, 2018, https://www.aljazeera.com/indepth/features/2017/06/50-years-israeli-occupation-longest-modern-history-170604111317533.html.

19. Cobban, "Roots of Resistance."

20. "Israel Declines to Study Rabin Tie to Beatings," *The New York Times*, July 12, 1990, https://www.nytimes.com/1990/07/12/world/israel-declines-to-study-rabin-tie-to-beatings.html.

21. This phrase was often used after the signing of the Oslo agreements. "Political Economy of Palestine," *Institute for Palestine Studies*, accessed February 11, 2021, https://oldwebsite.palestine-studies.org/ar/node/198424.

22. Abu Sitta, *Mapping My Return*, 317.

23. Edward Said, cited in Abu Sitta, *Mapping My Return*, 187.

24. Abu Sitta, *Mapping My Return*, 299.

25. James Bennet, "Arafat Not Present at Gaza HQ," *The New York Times*, December 3, 2001, https://www.nytimes.com/2001/12/03/international/arafat-not-present-at-gaza-headquarters.html.

26. Ghada Karmi, "'The Worst Spot in Gaza': 'You Will Not Understand How Hard it is Here' Until You See This Checkpoint," *Salon*, May 31, 2015, https://www.salon.com/2015/05/31/the_worst_spot_in_gaza_you_will_not_understand_how_hard_it_is_here_until_you_see_this_checkpoint/.

27. Ghada Ageel, "Gaza: Horror Beyond Belief," *Electronic Intifada*, May 16, 2004, https://electronicintifada.net/content/gaza-horror-beyond-belief/5078.

28. Dennis J. Deeb II, *Israel, Palestine, and the Quest for Middle East Peace* (Maryland: University Press of America, 2013), 36.

29. Mark Tran, "Israel Declares Gaza 'Enemy Entity,'" *The Guardian*, September 19, 2007, https://www.theguardian.com/world/2007/sep/19/usa.israel1.

30. Indeed, the announcement in early 2020 of the Trump-Netanyahu "deal of the century" now seems to have made Israeli unilateralism a mainstay of US foreign policy in the Middle East. For more details, see Avi Shlaim, "How Israel Brought Gaza to the Brink of Humanitarian Catastrophe," *The Guardian*, January 7, 2008, https://www.theguardian.com/world/2009/jan/07/gaza-israel-palestine; Shlaim's article was also published under "Background and Context," in *Journal of Palestine Studies* 38, no. 3 (Spring 2009): 223–39, https://doi.org/10.1525/jps.2009.xxxviii.3.223.

31. Ghada Ageel, "Introduction," in *Apartheid in Palestine: Hard Laws and Harder Experiences*, ed. Ghada Ageel (Edmonton: University of Alberta Press, 2016), xxx.

32. Ageel, "Introduction," xxvi.

33. Cited in "Fears That Wheat Stocks Could Run Out in the Occupied Palestinian Territory within Three Weeks," press

release, OXFAM International, April 11, 2022, https://www.oxfam.org/en/press-releases/fears-wheat-stocks-could-run-out-occupied-palestinian-territory-within-three-weeks.

34. "Fears That Wheat Stocks Could Run Out."

35. "Unemployment Rate Increases in Palestine," *Asharq Al-Awsat*, May,2, 2022, https://english.aawsat.com/home/article/3623926/unemployment-rate-increases-palestine; "Timeline: The Humanitarian Impact of the Gaza Blockade," OXFAM International, accessed November 23, 2022, https://www.oxfam.org/en/timeline-humanitarian-impact-gaza-blockade.

36. Sara Roy, "The Gaza Strip: A Case of Economic De-Development," *Journal of Palestine Studies* 17, no. 1 (Autumn 1987): 56–88; Shlaim, "How Israel Brought Gaza to the Brink."

37. "World Bank Warns, Gaza Economy is Collapsing," *Al Jazeera*, September 25, 2016, https://www.aljazeera.com/news/2018/09/world-bank-warns-gaza-economy-collapsing-180925085246106.html.

38. Eva Illouz, as cited and discussed in Ghada Ageel, "Gaza Under Siege: The Conditions of Slavery," *Middle East Eye*, January 19, 2016, https://www.middleeasteye.net/opinion/gaza-under-siege-conditions-slavery.

39. Ghada Ageel, "Where is Palestine's Martin Luther King?" *Middle East Eye*, June 26, 2018, https://www.middleeasteye.net/opinion/where-palestines-martin-luther-king-shot-or-jailed-israel.

40. Trew, "The UN Said Gaza Would be Uninhabitable by 2020."

41. David Halbfinger, Isabel Kershner, and Declan Walsh, "Israel Kills Dozens at Gaza Border as U.S. Embassy Opens in Jerusalem," *The New York Times*, May 14, 2018, https://www.nytimes.com/2018/05/14/world/middleeast/gaza-protests-palestinians-us-embassy.html.

42. Darwish, "Those Who Pass Between Fleeting Words."

43. Edward W. Said, "Invention, Memory and Place," *Critical Inquiry* 26, no. 2 (Winter 2000): 175–92.

44. Jonathan Adler, "Remembering the Nakba: The Politics of Palestinian History," *Jadaliyya*, July 17, 2018, https://www.jadaliyya.com/Details/37786.

45. Ilan Pappe, *The Ethnic Cleansing of Palestine* (Oxford: One World Publications, 2006), 231. Pappe attributes the term *memoricide* to Meron Benvenisti, *Sacred Landscape: The Buried History of the Holy Land Since 1948* (Berkeley: University of California Press, 2002).

46. As cited in John Randolph LeBlanc, *Edward Said on the Prospects of Peace in Palestine and Israel* (New York: Palgrave Macmilllan, 2013), 44.

47. Sonia Nimr, "Fast Forward to the Past: A Look into Palestinian Collective Memory," *Cahiers de Littérature Orale*, no. 63-64 (January 2008): 340, https://doi.org/10.4000/clo.287.

48. See Peter M. Jones, "George Lefebvre and the Peasant Revolution: Fifty Years On," *French Historical Studies* 16, no. 3 (Spring 1990): 645-63.

49. "Oral History: Defined," *Oral History Association*, accessed February 11, 2021, https://www.oralhistory.org/about/do-oral-history/.

50. Paul Thompson, *The Voice of the Past: Oral History* (Oxford: Oxford University Press, 1978), 25, https://tristero.typepad.com/sounds/files/thompson.pdf.

51. Alistair Thomson, "Four Paradigm Transformations in Oral History," *The Oral History Review* 34, no. 1 (2007): 52-53.

52. Rosemary Sayigh, "Oral History, Colonialist Dispossession, and the State: The Palestinian Case," *Settler Colonial Studies* 5, no. 3 (2015): 193.

53. Sherna Berger Gluck, "Oral History and al-Nakbah," *The Oral History Review* 35, no. 1 (2008): 68.

54. Edward W. Said, "Permission to Narrate," *Journal of Palestine Studies* 13, no. 3 (Spring 1984): 27-48.

55. Gluck, "Oral History and al-Nakbah," 69.

56. Malaka Mohammad Shwaikh, "Gaza Remembers: Narratives of Displacement in Gaza's Oral History," in *An Oral History of the Palestinian Nakba*, ed. Nahla Abdo and Nur Masalha (London: Zed Books, 2018), 16, https://www.researchgate.net/publication/329130803_Narratives_of_Displacement_in_Gaza's_Oral_History_2.

57. Edward Said, cited in Alan Lightman, "The Role of the Public Intellectual," *MIT Communications Forum*, accessed February 11, 2021, http://web.mit.edu/comm-forum/legacy/papers/lightman.html.

58. Sayigh, "Oral History," 193.

59. Edward Said, "On Palestinian Identity: A Conversation with Salman Rushdie (1986)," in *The Politics of Dispossession: The Struggle for Self Determination, 1969–1994* (New York: Pantheon Books, 1994), 126.

60. "Nakba's Oral History Interviews Listing," *PalestineRemembered.com*, March 31, 2004, https://www.palestineremembered.com/OralHistory/Interviews-Listing/Story1151.html.

61. Ahmad Sa'di and Lila Abu-Lughod, "Introduction: The Claims of Memory," in *Nakba: Palestine, 1948, and the Claims of Memory*, ed. Ahmad Sa'di and Lila Abu-Lughod (New York: Columbia University Press, 2007), 3.

62. Said cited in Lightman, "The Role of the Public Intellectual."

63. Quoted in Maria Fantappie and Brittany Tanasa, "Oral Historian Rosemary Sayigh Records Palestine's Her-Story in *Voices: Palestinian Women Narrate Displacement*," *Wowwire* (blog), *W4*, September 20, 2011, https://www.w4.org/en/wowwire/palestinian-women-narrate-displacement-rosemary-sayigh/.

64. Isabelle Humphries and Laleh Khalili, "Gender of Nakba Memory," in *Nakba: Palestine, 1948, and the Claims of Memory*, ed. Ahmad Sa'di and Lila Abu-Lughod (New York: Columbia University Press, 2007), 209.

65. Humphries and Khalili, "Gender of Nakba Memory," 209.

66. Humphries and Khalili, "Gender of Nakba Memory," 223.

67. Sayigh, *Voices: Palestinian Women*.

68. Fatma Kassem, *Palestinian Women: Narrative Histories and Gender Memory* (London: Zed Books, 2011), 1.

69. Sayigh, *Voices: Palestinian Women*.

70. "World Directory of Minorities and Indigenous Peoples—Palestine: Christians," Minority Rights Group International, May 2018, https://www.refworld.org/docid/49749cd12.html; and "Church Leaders: Palestinian Christians Face Threat of 'Extinction' from 'Radical' Israeli Groups," *Palestine Chronicle*, December 21, 2021, https://www.palestinechronicle.com/church-leaders-palestinian-christians-face-threat-of-extinction-from-radical-israeli-groups/.

71. Ramzy Baroud, "The Ethnic Cleansing of Palestinian Christians That Nobody Is Talking About," *Middle East Monitor*, October 29, 2019, https://www.middleeastmonitor.com/20191029-the-ethnic-cleansing-of-palestinian-christians-that-nobody-is-talking-about/; "World Directory of Minorities and Indigenous Peoples."

72. Cited in Baroud, "The Ethnic Cleansing."

73. "World Directory of Minorities and Indigenous Peoples."

74. "Christian Leader in Jerusalem: We'll Die in Defence of Al-Aqsa Mosque," *Middle East Monitor*, April 14, 2022, https://www.middleeastmonitor.com/20220414-christian-leader-in-jerusalem-well-die-in-defence-of-al-aqsa-mosque/.

75. "World Directory of Minorities and Indigenous Peoples."

76. "Christian Leader in Jerusalem"; Raseef22, "Jerusalem Christians: 'We Shrunk from 20% to 2% of Population Due to Israeli Violence,'" *Global Voices*, January 31, 2022, https://globalvoices.org/2022/01/31/jerusalem-christians-we-shrunk-from-20-to-2-of-population-due-to-israeli-violence/.

77. Baroud, "The Ethnic Cleansing."

78. See "World Directory of Minorities and Indigenous Peoples"; Baroud "The Ethnic Cleansing."

79. "Christian Leader in Jerusalem." See also Bill Dienst, "Gaza's Father Manuel," *Electronic Intifada*, January 6, 2007, https://electronicintifada.net/content/gazas-father-manuel/6663.

80. "Christian Leader in Jerusalem."

1 / CHILDHOOD

1. The annotations in this and the following chapters have been provided by the editors to add context to the story and are not the narrator's words. In addition, although the narrator's story has been translated and edited for length and clarity, her thoughts and opinions herein are her own and are expressed in her words. Editorial clarifications in the text have been set in square brackets.

2. In 1882 and with the support of the colonial British officials, missionaries started their mission work in Palestine. They established a medical mission in Gaza. In 1907, they established the Church Mission Society (CMS) Hospital, also known as the English or Baptist Hospital. That hospital earned support from the Ottoman authorities that controlled Gaza then. It was operated by Anglo-American missionaries for nearly a century. For more details on the CMS in Gaza and the history of the Baptist Hospital, see Carlton Carter Barnett III, "Anglo-American Missionary Medicine in Gaza, 1882–1981" (master's thesis, University of Texas at Austin, 2021), https://repositories.lib.utexas.edu/handle/2152/87222.

3. The Baptist, Church Mission Society, English, Ahli Arab, and Serling Hospitals are all one and the same. The Sterling name comes from Dr. R.G. Sterling. Before studying medicine, Dr. Sterling was a minister in the Anglican Church. He saw medicine as a means to an end—evangelism—and saw Gaza as fertile ground for missionary work. Dr. Sterling arrived in Gaza in 1891 and established the Dar 'Abd an-Dar Hospital. In the

early 1900s, Dr. Sterling started lobbying for a new hospital to be built, and began raising funds for it. This was to be the CMS Hospital, and was managed by Dr. Sterling himself. For more Information See Barnett, "Anglo-American Missionary Medicine."

4. Yusra Al-Barbari was one of the most important leaders in Palestinian nationalism. Upon her graduation from Cairo University in 1949, Yusra started her career as a teacher, then was promoted to headmistress, and finally became a school inspector in social studies. She was on the first Palestinian delegation to visit the United Nations in 1963, joining civil society leaders Dr. Haidar Abd Al Shafi and Ibrahim Abu Sitta. When Israel occupied the Gaza Strip, Al-Barbari refused to work under the occupation's civil administration, and she resigned from her job as inspector. Because of her political activities and community work, Al-Barbari endured constant harassment from Israeli authorities, and in 1974 she was prohibited from leaving the Gaza Strip for several years. She founded and headed several initiatives and societies, including the General Union of Palestinian Women and the Red Crescent Society. For more details, see Jean-Pierre Filiu, *Gaza: A History* (Oxford: Oxford University Press, 2014).

5. The Mamluk Dynasty ruled what is now Palestine (then part of the Levant) and Egypt for about two centuries. In 1291, the Mamluk forces laid siege on and captured the coastal city of Acre, the final stronghold in this area. They also defeated the Mongols and rescued the Arabic–Islamic civilization from destruction. For mor information, see W.B. Bartlett, *The Fall of Christendom: The Road to Acre, 1291* (Stroud: Amberley Publishing, 2022).

6. Al Saraya was the Turkish name for the Turkish government's head offices in Palestine during the Ottoman Empire. When Palestine was placed under the administration of the British Mandate, Al Saraya became the British headquarters. Over the

decades that followed, the building became the headquarters for whoever ruled Gaza, including the Egyptian administration (1949–1967), the Israelis during their military occupation (1967–1994), and finally, the Palestinians after signing the Oslo Accords (1994–2008). The Al Saraya building was completely destroyed in the 2008–2009 Israeli offensive on Gaza. For more details, see Khaldun Bshara, "The Ottoman Saraya: All That Did Not Remain," *Jerusalem Quarterly* 69 (Spring 2017): 66–77, https://www.palestine-studies.org/en/node/213043; and Khaldun Bshara and Shukri Arraf, *All That Did Not Remain* (Ramallah: Riwaq, 2016).

2 / THE BRITISH MANDATE AND SCHOOL DAYS

1. In 1929, the British police led a campaign to hunt down and arrest the *Fedayeen* who participated in the 1929 uprising, which started in Jerusalem then spread to the rest of Palestine in protest of British Mandate rule and the colonization of Palestine. Among the *Fedayeen* were Mohammad Jamjoum, 'Ata Al Zier, and Fouad Hijazi, who were imprisoned in Acre Prison and then hanged in front of thousands of people. For more details, see Kayyali, 'Abd al-Wahhab, *Wathā 'iq al-Muqāwama al-Filastīniyya al-'Arabiyya did al-Ihtilāl al-Britānī wa al-Zioniyya, 1918–1939* [Documents of the Palestinian Arab Resistance against the British and Zionist occupation] (Beirut Institute for Palestine Studies, 1967).

2. In Arabic, the chants are, from first to last, *Falasteen arabiyah min almayah lal Mayah*, meaning that Palestine is an Arab land from the Jordan river to the Mediterranean sea; *Yasqoud, Yasqout Al-lingleez*; and *Falasteen bitnadi: Ta'alu ya awaldi, Ihmou el-ard, Ihmou el-'ard*.

3. Miss Helen Ridler was the inspector of girls' schools in Palestine and the principal of the Women's Training College during the British Mandate era. For more details, see Madeeha

Hafez Albatta, *A White Lie*, eds. Ghada Ageel and Barbara Bill
(Edmonton: University of Alberta Press, 2020), 26.

4. The British medical missionaries' goal was to expose Gazan
 residents and patients to the gospel message. The CMS
 employees prayed and read verses of the Bible to all their
 patients. These attempts to convert people failed. Reflecting on
 that failure, the missionaries said that "the deadening power of
 Mohammedanism" had hardened the hearts of Gazans. Church
 Missionary Society and *Church Missionary Atlas*, cited in
 Barnett, "Anglo-American Missionary Medicine in Gaza," 20, 26.

5. Dr. A.R. Hargreaves, another British missionary physician,
 became director of the CMS Hospital in March 1929, replacing
 the younger Dr. Sterling (R.G. Sterling's son), who left the CMS
 Hospital in 1928.

6. 'Omar Al Mukhtar Street is Gaza City's main high street. It
 is full of shops, cafés, restaurants, banks, and government
 centres. It connects Gaza's Old City with the Mediterranean. It
 was named after the Libyan freedom fighter and hero 'Omar Al
 Mukhtar, who fought against Italian colonization in Libya.

7. Al Montar is the highest point in the Gaza Strip. An annual
 festival used to be held there every year in April, going back
 to the twelfth century. It was well attended, attracting people
 from all over Palestine, especially the people of Gaza district
 villages. The festival would usually last for a few days and
 included circus performances, poetry and literature, folk and
 religious songs, horse racing, and farmers markets. The festival
 was formally stopped in 1956 after the Israeli attack on and
 occupation of the Strip.

8. Hammam Al Samra is one of the original five Turkish
 bathhouses in Gaza. It is the only one that is still open. A
 sign at the entrance to the bath indicates that it was restored
 during the Mamluk Dynasty, around the year 1320, meaning
 that it was built before this. The United Nations Development
 Programme, working with the Islamic University in Gaza,

restored the *hammam* again in the early 2000s. It holds social importance, especially to women, as a place where community members come together to socialize. See United Nations Development Programme, "Hamam As-Sumara," in "Cultural Heritage," special issue, *UNDP FOCUS* 1 (2004): 11, https://fanack.com/wp-pdf-reader.php?pdf_src=/wp-content/uploads/2014/archive/user_upload/Documenten/Links/Occupied_Palestinian_Territories/UNDP_Focus_2004.pdf.

9. Palestinian Arabs revolted in 1936, terrified by the large number of Jewish immigrants that threatened Palestinians' rights and the demographic fabric of the country. The revolt was also a response to British policies that permitted this influx of immigrants. This Great Arab Revolt lasted for three years. A six-month national strike was declared at the beginning of the revolt and national committees were created in every corner of Palestine to fight both the British occupation and the Zionist militia groups. Eventually the revolution was brutally crushed by the British. According to Abu Sitta, at least five thousand Palestinians were killed and nearly 50 percent of all adult men living in the area that is now called the West Bank were injured or jailed. See Abu Sitta, *Mapping My Return*; Rawan Damen, dir., *Al Nakba* (Qatar: Al Jazeera Arabic, 2008; reversioned in English by Al Jazeera World, 2013), https://remix.aljazeera.com/aje/PalestineRemix/al-nakba.html#watch; Albatta, *A White Lie*, xviii.

3 / MARRIAGE AND RELATIONS WITH PALESTINIAN MUSLIMS

1. In other words, Hekmat's house had tap water—something that was rare at the time.

4 / BUSINESS AND LIFE BEFORE AND AFTER THE 1948 *NAKBA*

1. Jaffa, one of the largest cities in historic Palestine, had a vibrant and educated Palestinian middle class. Like Beirut and Cairo, it was a centre for cultural life. The major Palestinian

newspapers and publication centres were located in Jaffa. It also housed several cultural centres and cinemas, including the famous Alhamra Cinema, opened in 1937. In addition to screenings, Alhamra became a hub for Arab cultural activity in the 1930s. Famous Arab singers, including the Egyptian singer Umm Kulthum, performed there.

2. Because of a Jewish religious belief that Gaza is a cursed land, few Jews lived in Gaza. Those that did lived mainly in Al Zaitoon, in what used to be known as the Jewish quarter. They owned a few houses, had their own cemetery, and were probably from the same extended family. These were Palestinian Jews who lived in harmony with their Palestinian Christian and Muslim neighbours. Gazan historian Nasser al-Yafawi (quoted in Al Gherbawi, "The Lost History") confirmed that before the occupation of Gaza, "Palestinians did not view the Jews as enemies. Jews undertook commercial projects and owned land. The relationship between the Muslim and Jewish communities was fraternal until the emergence of Zionism and the project of occupying Palestine." After Israel occupied the Gaza Strip in 1967, the Palestinian Jewish families left. Following the order of then Defence Minister Moshe Dayan, the remains of Palestinian Jews who were buried in Gaza's Jewish cemetery were also removed from Gaza to Israel. Hadeel Al Gherbawi, "The Lost History of Gaza's Jewish Quarter," *Al Monitor*, December 23, 2021, https://www.al-monitor.com/originals/2021/12/lost-history-gazas-jewish-quarter#ixzz7czUHiQxP.

5 / THE PALESTINIAN RESISTANCE AGAINST THE BRITISH MANDATE

1. For more details see Abu Sitta, *Mapping My Return*, 35-60.
2. The UN Relief and Works Agency for Palestine Refugees (UNRWA) is a relief and human development agency that supports more than five million registered Palestinian refugees

and their descendants, who were expelled from their homes during the 1948 *Nakba*. It was established by UN General Assembly Resolution 302 (IV), *Assistance to Palestine Refugees*, A/RES/302 (IV), December 8, 1949, https://www.unrwa.org/content/general-assembly-resolution-302.

3. Dr. Haidar Abd Al Shafi was a towering figure of the Palestinian national movement and Palestinian civil society. He was a physician, an activist, a community and political leader, and a tremendously popular figure. Due to this popularity, he was elected to the Palestinian Legislative Council, receiving more votes than any other candidate. He headed the Palestinian delegation at the Madrid Conference of 1991. He also established the Palestinian Red Crescent Society in the Gaza Strip, which began by delivering free medical care and then became a forum for cultural activities. This provided the base of his grassroots political support. Because of his activism, he was detained by Israel several times. In 1969, he was exiled for three months in Sinai Peninsula. He was then deported to Lebanon in 1970, where he remained for two months. For more details, see Victoria Britain, "Haider Abdel-Shafi: Militant and Popular Leader Respected by Rival Palestine Factions," *The Guardian*, September 26, 2007.

6 / THE EGYPTIAN ADMINISTRATION AND THE ISRAELI OCCUPATION

1. For more details on the Khan Yonis massacre, see Albatta, *A White Lie*, 51–64.

7 / YUSUF, THE UNITED STATES, AND PALESTINE

1. The 1994 Agreement on the Gaza Strip and Jericho Area (a follow-up agreement to the Oslo I Accord), and the 1995 Israeli–Palestinian Interim Agreement on the West Bank and the Gaza Strip (also known as the Oslo II Accord) established that the Palestinian Authority has the right to

issue "passports/travel documents" to Palestinians living in the West Bank and the Gaza Strip. This passport replaced the Egyptian travel documents that had been issued to Gazans since 1948 and enabled thousands to travel to the Arab world seeking education or work. See UN General Assembly, Israeli-Palestinian Interim Agreement on the West Bank and the Gaza Strip (a.k.a. "Oslo II"), A/51/889-S/1997/357, September 28, 1995, https://www.un.org/unispal/document/auto-insert-185434/; UN General Assembly, Agreement on the Gaza Strip and the Jericho Area: Palestinian Authority, International Presence, Paris Protocol, A/49/180-S/1994/727, May 4, 1994, https://www.un.org/unispal/document/auto-insert-185298/.

2. The Balfour Declaration was issued by British Foreign Secretary Arthur James Balfour in 1917. It promised support for the establishment of a "national home for the Jewish people" in Palestine, then an Ottoman region with a small, minority Jewish population. The declaration, which was included in the terms of the British Mandate over Palestine, is widely viewed as one of the main catalysts of the *Nakba*. For more information, see Zena Tahhan, "More Than a Century On: The Balfour Declaration Explained," *Al Jazeera*, November 2, 2018, https://www.aljazeera.com/features/2018/11/2/more-than-a-century-on-the-balfour-declaration-explained.

CHRONOLOGY OF EVENTS IN PALESTINE

1. The following works were consulted when compiling this chronology of events in Palestine: Walid Khalidi, ed., *All That Remains: The Palestinian Villages Occupied and Depopulated by Israel in 1948* (Washington, DC: Institute for Palestine Studies, 1992); Mahdi F. Abdul Hadi, ed., *Documents On Palestine, Volume I: From the Pre-Ottoman/Ottoman Period to the Prelude of the Madrid Middle East Peace Conference* (Jerusalem: Palestinian Academic Society for the Study of International Affairs, 1997); Said K. Aburish, *A Brutal Friendship: The West*

and the Arab Elite (New York: St. Martin's Press, 1998); PASSIA Diary 1999 (Jerusalem: Palestinian Academic Society for the Study of International Affairs, 1998); PASSIA Diary 2001 (Jerusalem: Palestinian Academic Society for the Study of International Affairs, 2000); Ilan Pappe, The Ethnic Cleansing of Palestine (Oxford: Oneworld Publications, 2006); Rashid Khalidi, The Iron Cage: The Story of the Palestinian Struggle for Statehood (Boston: Beacon Press, 2006); Linda Butler, "A Gaza Chronology, 1948–2008," Journal of Palestine Studies 38, no. 3 (2009): 98–121, https://doi.org/10.1525/jps.2009.XXXVIII.3.98; "A Lot of Process, No Peace: A Timeline of 20 Years of Post-Oslo Meetings, Agreements, Negotiations and Memorandums," Perspectives: Political Analyses and Commentary from the Middle East & North Africa 5 (December 2013), 5–8; Amira Hass, Drinking the Sea at Gaza: Days and Nights in a Land Under Siege (New York: Henry Holt and Company, 2014); PASSIA Diary 2018 (Jerusalem: Palestinian Academic Society for the Study of International Affairs, 2017); "Palestine: What Has Been Happening Since WWI," Al Jazeera, May 14, 2018, https://www.aljazeera.com/focus/arabunity/2008/02/20085251908164329.html; Eóin Murray and James Mehigan, eds., Defending Hope: Dispatches from the Front Lines in Palestine and Israel (Dublin: Veritas Books, 2019); Chloé Benoist, "'The Deal that Can't be Made': A Timeline of the Trump Administration's Israel-Palestine Policy," Middle East Eye, January 28, 2020, https://www.middleeasteye.net/news/deal-cant-be-made-timeline-trump-administrations-israel-palestine-policy; Rashid Khalidi, The Hundred Years' War on Palestine: A History of Settler Colonialism and Resistance, 1917–2017 (New York: Metropolitan Books, 2020); "Timeline: Israel's Attacks on Gaza since 2005," Al Jazeera, August 7, 2022, https://www.aljazeera.com/news/2022/8/7/timeline-israels-attacks-on-gaza-since-2005.

Glossary

Al 'Awameed: An area in the Old City of Gaza that has several
huge rows of ancient marble columns.

Al Daraj: A suburb of Gaza's Old City.

Al Montar: The highest place in Gaza, north-east of Gaza City.

Al Saraya: The Turkish government's head offices in Palestine
during the Ottoman Empire. The building was destroyed in the
2008-2009 Israeli offensive in Gaza.

Al Zaitoon: The oldest and largest suburb that is located in the Old
City of Gaza.

'arayis: Handmade bride dolls. The outline of the doll was drawn
on fabric, and then cut, sewn, and filled with scrap fabric or
whatever was available.

arqila: Traditional Arab water pipe; also called *sheesha* or *narqila*.

boqja: A velvet bag covered with silk embroidery, like a cushion
cover, made especially for public baths. People carried these bags
to show that they were well off.

borbara: A traditional Gaza desert of cooked wheat berries, raisins,
and sugar, with nuts on top.

dabkeh: A traditional Arab folk dance that has been performed for
thousands of years. It is mainly performed across the Levant
(Syria, Palestine, Jordan, and Lebanon) as well as in Iraq.

dunum: Measurement of land used in Palestine, equal to one thou-
sand square metres.

fanoos (pl. fawanees): A decorative lamp made of bronze or glass. Children usually carry small *fawanees* during Ramadan.

Feda'i (pl. Fedayeen): Resistance fighter. In this book, *Feda'i* or *Fedayeen* refer to those who left their families and homes, were organized and trained, and became wanted men, as opposed to villagers and citizens who organized themselves to defend their land against enemy attacks.

Hammam Al Samra: One of the original five Turkish bath-houses in Gaza, and the only one that continues to function. It holds social importance, especially to women, as a place where community members come together to socialize.

haram: Religiously impure or bad; refers to an unacceptable behaviour or thing. Opposite of *halal* which means religiously pure or correct.

hommus: Crushed chickpeas mixed with sesame paste, garlic, lemon juice, and olive oil, and eaten with bread; a traditional dish of the people of Sham.

Intifada: Literally means "waking in a fright." Refers to the popular Palestinian uprising against the Israeli occupation, which started in December 1987 and ended in 1993 with the signing of the Declaration of Principles. The second *Intifada*, known as *Al Aqsa Intifada*, started in September 2000 and ended in 2006.

ka'k: Refers to *ka'k al 'Eid*. Date paste enclosed in biscuit dough, which is rolled, joined in a circle, and cooked, then dusted with icing sugar. Especially popular at *'Eid Al Fitr*.

mahshi: Popular Palestinian dish of eggplants or squash stuffed with meat and rice, usually served with a tomato sauce.

malleem: A small denomination of Palestinian currency. Before the *Nakba* and the destruction of Palestine, a *malleem* was one tenth of a *qersh*.

molokhia: A type of mallow, the leaves of which are finely chopped and made into a popular Palestinian soup.

muhajir (pl. muhajreen): literally, immigrants. Refers to a Palestinian refugee who was forced to flee their home during the Mandate period in Palestine or were displaced within Palestine during the 1948 war. Similar to the word *laji'* (pl. *laji'een*), which literally means refugee.

Nakba: Literally, the catastrophe. Refers to the mass expulsion of Palestinian Arabs from British Mandate Palestine during Israel's creation between 1947 and 1949.

qersh: A small denomination of Palestinian currency. Before the *Nakba* and the destruction of Palestine, a *qersh* was equal to one one-hundredth of a Palestinian pound.

Ramadan: Islamic holy month during which there is fasting during daylight hours and a meal at nightfall and before daybreak

Rimal: Literally, sands. A southern suburb of Gaza City.

shash (pl. shashat): Traditional Palestinian women's long head-dress, which covers the upper body to the waist. Sometimes twisted and tied at the waist of a *towb*, like a belt.

Shuja'yya: An eastern suburb of Gaza City.

sumaqiya: Traditional Gazan dish of vegetables, meat, sumac and other species, made on special occasions, such as weddings or after Ramadan.

Sumud: Steadfastness.

tawjihi: Graduating or senior certificate from high school, the results of which determine whether the student is eligible for university study.

towb (pl. tiab): Traditional Palestinian women's long, embroidered gown with long sleeves. Each Palestinian village had a particular embroidery pattern that distinguished it and its people from other villages.

Bibliography

'Abd al-Wahhab, Kayyali. *Wathā 'iq al-Muqāwama al-Filastīniyya* 149
al-'Arabiyya did al-Ihtilāl al-Britānī wa al-Zioniyya, 1918–1939
[Documents of the Palestinian Arab Resistance against the
British and Zionist occupation]. Beirut Institute for Palestine
Studies, 1967.

Abdo, Nahla, and Nur Masalha, eds. *An Oral History of the
Palestinian Nakba*. London: Zed Books, 2018.

Abu Jaber, Ibrahim, Wisam Afifi, Maisam Eid, et al. *Jurh Al-Nakba:
Part 1* [The wound of the *Nakba*: Part 1]. Um Al-Fahem: Centre
of Contemporary Studies, 2003.

Abu Laban, Yasmeen, and Abigail B. Bakan. *Israel, Palestine and the
Politics of Race*. London: I.B. Tauris, 2019.

Abu Sharif, Bassam. *Arafat and the Dream of Palestine: An Insider's
Account*. New York: Palgrave Macmillan, 2009.

Abu Sitta, Salman. "Gaza Strip: The Lessons of History." *Palestine
Land Society*. 2016. http://www.plands.org/en/articles-speeches/
articles/2016/gaza-strip-the-lessons-of-history.

Abu Sitta, Salman. *Mapping My Return: A Palestinian Memoir*. Cairo
and New York: The American University in Cairo Press, 2016.

Adler, Jonathan. "Remembering the Nakba: The Politics of
Palestinian History." *Jadaliyya*, July 17, 2018. https://www.
jadaliyya.com/Details/37786.

Ageel, Ghada, ed. *Apartheid in Palestine: Hard Laws and Harder
Experiences*. Edmonton: University of Alberta Press, 2016.

Ageel, Ghada. "Gaza: Horror Beyond Belief." *Electronic Intifada*, May 16, 2004. https://electronicintifada.net/content/gaza-horror-beyond-belief/5078.

Ageel, Ghada. "Gaza Under Siege: The Conditions of Slavery." *Middle East Eye*, January 19, 2016. https://www.middleeasteye.net/opinion/gaza-under-siege-conditions-slavery.

Ageel, Ghada. "Introduction." In *Apartheid in Palestine*, edited by Ghada Ageel, xxv–xliv. Edmonton: University of Alberta Press, 2016.

Ageel, Ghada. "Where Is Palestine's Martin Luther King?" *Middle East Eye*, June 26, 2018. https://www.middleeasteye.net/opinion/where-palestines-martin-luther-king-shot-or-jailed-israel.

Agha, Ihsan Khalil. *Khan Yunis wa shuhada'iha* [Khan Younis martyrs]. Cairo: Markaz Fajr Publishing, 1997.

Al-Barbari, Sahbaa. *Light the Road of Freedom*. Edited by Ghada Ageel and Barbara Bill. Edmonton: University of Alberta Press, 2021.

Albatta, Madeeha Hafez. *A White Lie*. Edited by Ghada Ageel and Barbara Bill. Edmonton: University of Alberta Press, 2020.

Al Gherbawi, Hadeel. "The Lost History of Gaza's Jewish Quarter." *Al Monitor*, December 23, 2021. https://www.al-monitor.com/originals/2021/12/lost-history-gazas-jewish-quarter#ixzz7czUHiQxP.

Amr, Nabil. *Yasser Arafat and the Madness of Geography*. Cairo: Dar Al Shuruq, 2012.

Awad, Alex. *Palestinian Memoires: The Story of Palestinian Mother and Her People*. Self-published, Kindle Editions, 2008.

BADIL. *Survey of Palestinian Refugees and Internally Displaced Persons 2016–2018*. Vol. IX. Bethlehem: BADIL Resource Center for Palestinian Residency & Refugee Rights, 2019. http://www.badil.org/phocadownloadpap/badil-new/publications/survay/survey2016-2018-eng.pdf.

Barghouti, Mourid. *I Was Born There, I Was Born Here*. New York: Walker & Company, 2012.

Barnett, Carlton Carter, III. "Anglo-American Missionary Medicine in Gaza, 1882–1981." Master's thesis, University of Texas at Austin, May 2021. https://repositories.lib.utexas.edu/handle/2152/87222.

Baroud, Ramzy. "The Ethnic Cleansing of Palestinian Christians That Nobody Is Talking About." *Middle East Monitor*, October 29, 2019. https://www.middleeastmonitor.com/20191029-the-ethnic-cleansing-of-palestinian-christians-that-nobody-is-talking-about/.

Baroud, Ramzy, ed. *Searching Jenin: Eyewitness Accounts of the Israeli Invasion*. Seattle: Cune Press, 2003.

Baroud, Ramzy. *My Father Was a Freedom Fighter: Gaza's Untold Story*. London: Pluto Press, 2010.

Bartlett, W.B. *The Fall of Christendom: The Road to Acre, 1291*. Stroud: Amberly Publishing, 2022.

Bennet, James. "Arafat Not Present at Gaza HQ." *The New York Times,* December 3, 2001. https://www.nytimes.com/2001/12/03/international/arafat-not-present-at-gaza-headquarters.html.

Benvenisti, Meron. *Sacred Landscape: The Buried History of the Holy Land Since 1948*. Berkley: University of California Press, 2002.

Britain, Victoria. "Haider Abdel-Shafi: Militant and Popular Leader Respected by Rival Palestine Factions." *The Guardian,* September 26, 2007.

Bshara, Khaldun. "The Ottoman Saraya: All That Did Not Remain." *Jerusalem Quarterly* 69 (Spring 2017): 66–77. https://oldwebsite.palestine-studies.org/sites/default/files/jq-articles/Pages%20from%20JQ%2069%20-%20Bshara.pdf.

Bshara, Khaldun, and Shukri Arraf. *All That Did Not Remain*. Ramallah: Riwaq, 2016.

"Christian Leader in Jerusalem: We'll Die in Defence of Al-Aqsa Mosque." *Middle East Monitor*, April 14, 2022. https://www.

middleeastmonitor.com/20220414-christian-leader-in-jerusalem-well-die-in-defence-of-al-aqsa-mosque/.

"Church Leaders: Palestinian Christians Face Threat of 'Extinction' from 'Radical' Israeli Groups." *Palestine Chronicle*, December 21, 2021. https://www.palestinechronicle.com/church-leaders-palestinian-christians-face-threat-of-extinction-from-radical-israeli-groups/.

Cobban, Helena. "Roots of Resistance: The First Intifada in the Context of Palestinian History." *Mondoweiss*, December 17, 2012. https://mondoweiss.net/2012/12/roots-of-resistance-the-first-intifada-in-the-context-of-palestinian-history/.

Damen, Rawan, dir. *Al Nakba*. Qatar: All Jazeera Arabic, 2008. Reversioned to English by Al Jazeera World, 2013. https://remix.aljazeera.com/aje/PalestineRemix/al-nakba.html#watch.

Darwish, Mahmoud. "Those Who Pass Between Fleeting Words." *Middle East Report* 154, September/October 1988. https://merip.org/1988/09/those-who-pass-between-fleeting-words/.

Deeb, Dennis J., II. *Israel, Palestine, and the Quest for Middle East Peace*. Maryland: University Press of America, 2013.

Dienst, Bill. "Gaza's Father Manuel." *Electronic Intifada*, January 6, 2007. https://electronicintifada.net/content/gazas-father-manuel/6663.

El-Haddad, Laila. *Gaza Mom: Palestine, Politics, Parenting, and Everything In Between*. Charlottesville, VA: Just World Books, 2010.

Fantappie, Maria, and Brittany Tanasa. "Oral Historian Rosemary Sayigh Records Palestine's Her-Story in *Voices: Palestinian Women Narrate Displacement*." *Wowwire* (blog). *W4*, September 20, 2011. https://www.w4.org/en/wowwire/palestinian-women-narrate-displacement-rosemary-sayigh/.

"Fears That Wheat Stocks Could Run Out in the Occupied Palestinian Territory within Three Weeks." Press release. OXFAM International, April 11, 2022. https://www.oxfam.org/en/press-releases/

fears-wheat-stocks-could-run-out-occupied-palestinian-
territory-within-three-weeks.

Filiu, Jean-Pierre. *Gaza: A History*. Oxford: Oxford University Press,
2014.

Gluck, Sherna Berger. "Oral History and al-Nakbah." The Oral
History Review 35, no. 1 (2008): 68-80.

Halbfinger, David M., Isabel Kershner, and Declan Walsh. "Israel
Kills Dozens at Gaza Border as U.S. Embassy Opens in
Jerusalem." *The New York Times*, May 14, 2018. https://www.
nytimes.com/2018/05/14/world/middleeast/gaza-protests-
palestinians-us-embassy.html.

Househ, Muwafa Said. *Under the Nakba Tree*. Athabasca University
Press, 2022.

Hroub, Khaled. *Hamas: Political Thought and Practice*. Washington,
D.C.: Institute for Palestine Studies, 2000.

Humphries, Isabelle, and Laleh Khalili. "Gender of Nakba
Memory." In *Nakba: Palestine, 1948, and the Claims of Memory*,
edited by Ahmad H. Sa'di and Lila Abu-Lughod, 207-28. New
York: Columbia University Press, 2007.

"Israeli Colonies and Israeli Colonial Expansion." CJPME Factsheet
Series No. 9. *Canadians for Justice and Peace in the Middle East*,
2005. https://www.cjpme.org/fs_009.

"Israel Declines to Study Rabin Tie to Beatings." *The New York
Times*, July 12, 1990. https://www.nytimes.com/1990/07/12/
world/israel-declines-to-study-rabin-tie-to-beatings.html.

Jones, Peter M. "George Lefebvre and the Peasant Revolution: Fifty
Years On." *French Historical Studies* 16, no. 3 (Spring, 1990):
645-63.

Karmi, Ghada. "'The Worst Spot in Gaza': 'You Will Not Understand
How Hard it is Here' Until You See This Checkpoint." *Salon*,
May 31, 2015. https://www.salon.com/2015/05/31/
the_worst_spot_in_gaza_you_will_not_understand_how_
hard_it_is_here_until_you_see_this_checkpoint/.

Kassem, Fatma. *Palestinian Women: Narrative Histories and Gender Memory*. London: Zed Books, 2011.

Khalidi, Walid. *Before Their Diaspora: A Photographic History of the Palestinians, 1876–1948*. Washington, DC: Institute for Palestine Studies, 1984.

LeBlanc, John Randolph. *Edward Said on the Prospects of Peace in Palestine and Israel*. New York: Palgrave MacMilllan, 2013.

LeVine, Mark. "Tracing Gaza's Chaos to 1948." *Al Jazeera*, July 13, 2009. https://www.aljazeera.com/news/2009/7/13/tracing-gazas-chaos-to-1948.

Lightman, Alan. "The Role of the Public Intellectual." *MIT Communications Forum*. Accessed February 11, 2021. http://web.mit.edu/comm-forum/legacy/papers/lightman.html.

Macintyre, Donald. "By 2020, the UN Said Gaza Would be Unliveable. Did It Turn Out that Way?" *The Guardian*, December 28, 2019. https://www.theguardian.com/world/2019/dec/28/gaza-strip-202-unliveable-un-report-did-it-turn-out-that-way.

Morris, Benny. *Israel's Border Wars, 1949–1956*. Oxford: Clarendon Press, 1993.

Murray, Eóin. "Under Siege." In *Defending Hope: Dispatches from the Front Lines in Palestine and Israel*, edited by Eóin Murray and James Mehigan, 29–46. Dublin: Veritas Books, 2018.

"Nakba's Oral History Interviews Listing." *Palestine Remembered*, March 31, 2004. https://www.palestineremembered.com/OralHistory/Interviews-Listing/Story1151.html.

Nimr, Sonia. "Fast Forward to the Past: A Look into Palestinian Collective Memory." *Cahiers de Littérature Orale* 63–64 (January 2008): 338–49. https://doi.org/10.4000/clo.287.

"Oral History: Defined." *Oral History Association*. Accessed February 11, 2021. https://www.oralhistory.org/about/do-oral-history/.

Pappe, Ilan. *The Ethnic Cleansing of Palestine*. Oxford: One World Publications, 2006.

"Political Economy of Palestine." *Institute for Palestine Studies.* Accessed February 11, 2021. https://oldwebsite.palestine-studies. org/resources/special-focus/political-economy-palestine.

Raseef22. "Jerusalem Christians: 'We Shrunk from 20% to 2% of Population Due to Israeli Violence.'" *Global Voices,* January 31, 2022. https://globalvoices.org/2022/01/31/ jerusalem-christians-we-shrunk-from-20-to-2-of-population- due-to-israeli-violence/.

Roy, Sara. "The Gaza Strip: A Case of Economic De-Development." *Journal of Palestine Studies* 17, no. 1 (Autumn 1987): 56–88.

Sa'di, Ahmad H., and Lila Abu-Lughod. "Introduction: The Claims of Memory." In *Nakba: Palestine, 1948, and the Claims of Memory,* edited by Ahmad H. Sa'di and Lila Abu-Lughod, 1–24. New York: Columbia University Press, 2007.

Said, Edward W. *Covering Islam: How the Media and the Experts Determine How We See the Rest of the World.* New York: Pantheon Books, 1981.

Said, Edward W. "Invention, Memory and Place." *Critical Inquiry* 26, no. 2 (Winter 2000): 175–92.

Said, Edward W. "On Palestinian Identity: A Conversation with Salman Rushdie (1986)." In *The Politics of Dispossession: The Struggle for Palestinian Self Determination, 1969–1994,* 107–29. New York: Pantheon Books, 1994.

Said, Edward W. "Permission to Narrate." *Journal of Palestine Studies* 13, no. 3 (Spring 1984): 27–48.

Sayigh, Rosemary. "Oral History, Colonialist Dispossession, and the State: the Palestinian Case." *Settler Colonial Studies* 5, no. 3 (2015): 193–204.

Sayigh, Rosemary. *The Palestinians: From Peasants to Revolutionaries.* London: Zed Books, 1979.

Sayigh, Rosemary. *Voices: Palestinian Women Narrate Displacement.* Al-Mashriq, 2005/2007. https://almashriq.hiof.no/ palestine/300/301/voices/.

Shlaim, Avi. "Background and Context." *Journal of Palestine Studies* 38, no. 3 (Spring 2009): 223-39. https://doi.org/10.1525/jps.2009.xxxviii.3.223.

Shlaim, Avi. "How Israel Brought Gaza to the Brink of Humanitarian Catastrophe." *The Guardian*, January 7, 2009. https://www.theguardian.com/world/2009/jan/07/gaza-israel-palestine. Also published as "Background and Context." *Journal of Palestine Studies* 38, no. 3 (Spring 2009): 223-39. https://doi.org/10.1525/jps.2009.xxxviii.3.223.

Shwaikh, Malaka Mohammad. "Gaza Remembers: Narratives of Displacement in Gaza's Oral History." In *An Oral History of the Palestinian Nakba*, edited by Nahla Abdo and Nur Masalha, 277-93. London: Zed Books, 2018. https://www.researchgate.net/publication/329130803_Narratives_of_Displacement_in_Gaza's_Oral_History_2.

"The State of the World's Refugees 2006: Human Displacement in the New Millennium." *United Nations High Commissioner for Refugees*, April 20, 2006. https://www.unhcr.org/publications/sowr/4a4dc1a89/state-worlds-refugees-2006-human-displacement-new-millennium.html.

Tahhan, Zena. "More Than a Century On: The Balfour Declataion Explained." *Al Jazeera,* November 2, 2018. https://www.aljazeera.com/features/2018/11/2/more-than-a-century-on-the-balfour-declaration-explained.

Tahhan, Zena. "The *Naksa*: How Israel Occupied the Whole of Palestine in 1967." *Al Jazeera*, June 4, 2018. https://www.aljazeera.com/indepth/features/2017/06/50-years-israeli-occupation-longest-modern-history-170604111317533.html.

Thompson, Paul. *The Voice of the Past: Oral History*. Oxford: Oxford University Press, 1978.

Thomson, Alistair. "Four Paradigm Transformations in Oral History." *The Oral History Review* 34, no. 1 (2007): 49-70.

"Timeline: The Humanitarian Impact of the Gaza Blockade."
OXFAM International. Accessed February 11, 2021, https://www.
oxfam.org/en/timeline-humanitarian-impact-gaza-blockade.

Tran, Mark. "Israel Declares Gaza 'Enemy Entity.'" *The Guardian*,
September 19, 2007. https://www.theguardian.com/
world/2007/sep/19/usa.israel1.

Trew, Bel. "The UN Said Gaza Would be Uninhabitable by 2020—In
Truth, It Already Is." *Independent*, December 29, 2019. https://
www.independent.co.uk/voices/israel-palestine-gaza-hamas-
protests-hospitals-who-un-a9263406.html.

"Unemployment Rate Increases in Palestine." *Asharq Al-Awsat*,
May,2, 2022. https://english.aawsat.com/home/
article/3623926/unemployment-rate-increases-palestine.

UN General Assembly. *Agreement on the Gaza Strip and the Jericho
Area: Palestinian Authority, International Presence, Paris Protocol.*
A/49/180-S/1994/727. May 4, 1994. https://www.un.org/
unispal/document/auto-insert-185298/.

UN General Assembly. *Israeli-Palestinian Interim Agreement on the
West Bank and the Gaza Strip (a.k.a. "Oslo II").*
A/51/889-S/1997/357. September 28, 1995. https://www.un.org/
unispal/document/auto-insert-185434/

UN General Assembly. Resolution 302 (IV). *Assistance to Palestine
Refugees.* A/RES/302 (IV). December 8, 1949. https://www.
unrwa.org/content/general-assembly-resolution-302.

United Nations. *Gaza in 2020: A Liveable Place?* August 2012.
https://www.unrwa.org/userfiles/file/publications/gaza/
Gaza%20in%202020.pdf.

United Nations Development Programme. "Hamam As-Sumara." In
"Cultural Heritage," special issue, *UNDP Focus* 1 (2004): 11.
https://fanack.com/wp-pdf-reader.php?pdf_src=/wp-content/
uploads/2014/archive/user_upload/Documenten/Links/
Occupied_Palestinian_Territories/UNDP_Focus_2004.pdf.

Veeser, H. Aram. *Edward Said: The Charisma of Criticism.* London:
Routledge, 2010.

"Where We Work, Gaza Strip." *United Nations Relief and Works Agency for Palestine Refugees in the Near East.* Accessed February 11, 2021. https://www.unrwa.org/where-we-work/gaza-strip.

"World Bank Warns, Gaza Economy is 'Collapsing.'" *Al Jazeera,* September 25, 2016. https://www.aljazeera.com/news/2018/09/world-bank-warns-gaza-economy-collapsing-180925085246106.html.

"World Directory of Minorities and Indigenous Peoples—Palestine: Christians." Minority Rights Group International, May 2018. https://www.refworld.org/docid/49749cd12.html

Other Titles from University of Alberta Press

Light the Road of Freedom
SAHBAA AL-BARBARI
Edited by GHADA AGEEL & BARBARA DILL
Personal story of a Palestinian woman, teacher,
and activist, from before and after the *Nakba*.
Women's Voices from Gaza Series

A White Lie
MADEEHA HAFEZ ALBATTA
Edited by BARBARA BILL & GHADA AGEEL
The personal story of a brave Palestinian woman's
fight for dignity and freedom.
Women's Voices from Gaza Series

Apartheid in Palestine
Hard Laws and Harder Experiences
Edited by GHADA AGEEL
Palestinian, Israeli, academic, and activist voices
gather to humanize ongoing debates over Israel
and Palestine.

More information at uap.ualberta.ca

Printed in the USA
CPSIA information can be obtained
at www.ICGtesting.com
CBHW021620150624
10117CB00012B/50